ANTIQUE BOTANICALS STUDIO
~ BOOK 1~
CIRCA – 1839-40

ISBN: 9781090757784

40 CREATE YOUR OWN ART PRINTS

As these original botanical prints are over 180 years old, we have painstakingly restored them to their original condition to the best of our ability. We've created a sketch of the original antique print.

If you'd like to use the same coloration as the original antique print you can visit our website at www.BotanicalArtDesigns.com/studio_originals to view each print or you can use your imagination and colorize your art print as you wish.

Each print is 5" x 7" which is a compatible size for the standard opening of an 8" x 10" mat.

You can use the print as is from the book or you may prefer to use high quality art paper recommended for the medium you are working in such as watercolor, acrylics, colored pencil, gel pen, etc.

We would also recommend archival quality, acid-free, 25% cotton, 24 lb. stock linen paper which will not yellow with age. It's readily available through any office supply store or online and it's not super expensive.

Thank you for your purchase. We hope you enjoy your book.

If you have any questions please feel free to contact us on our website at www.BotanicalArtDesigns.com

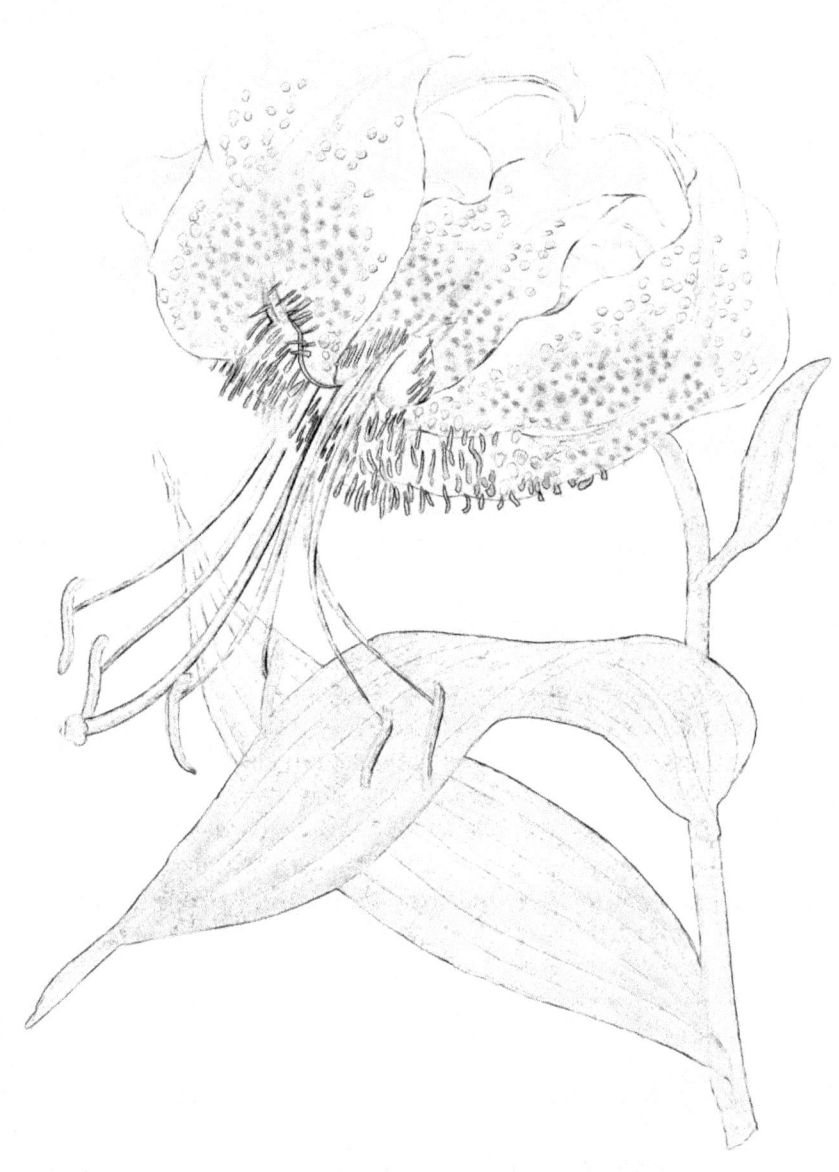

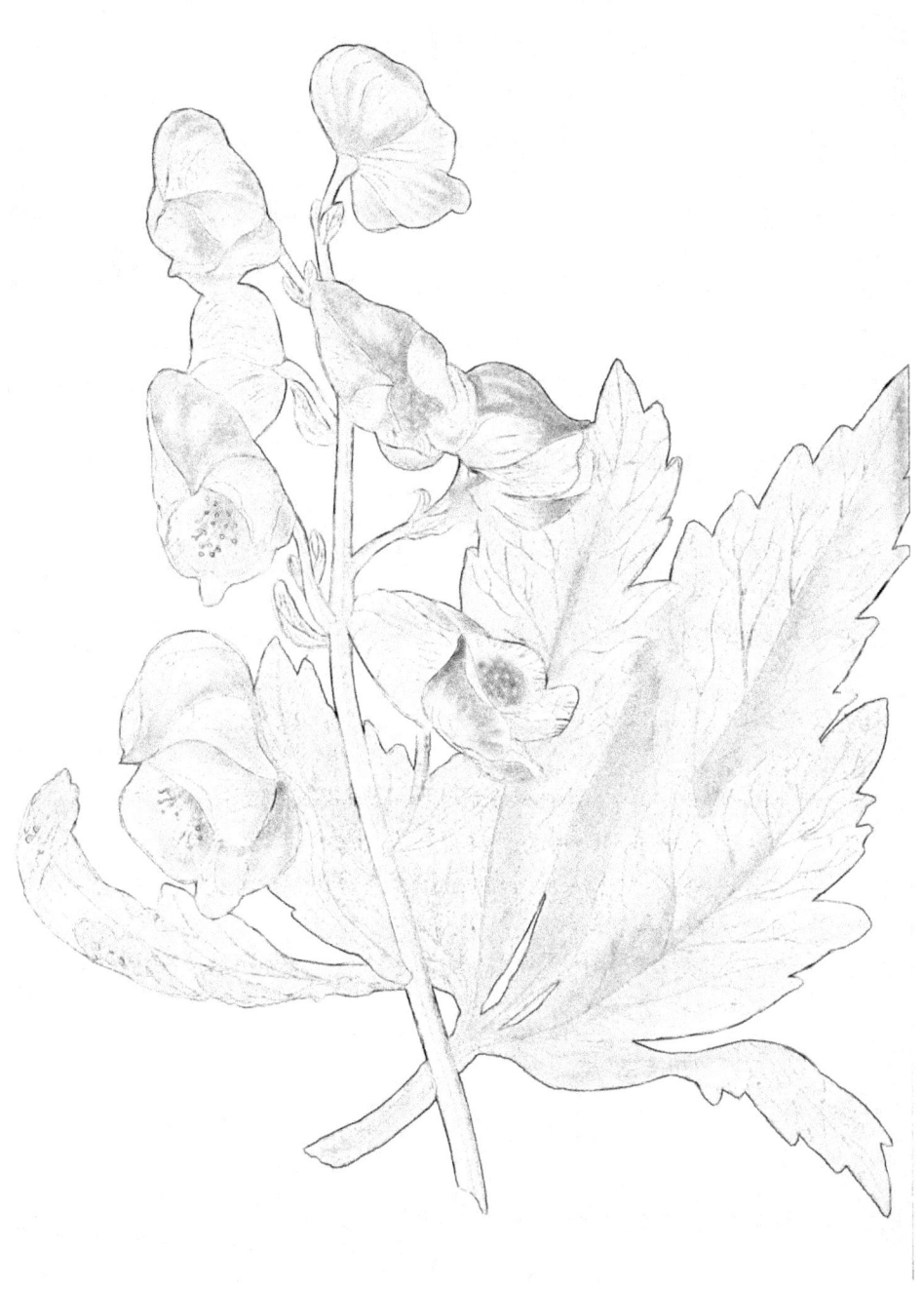

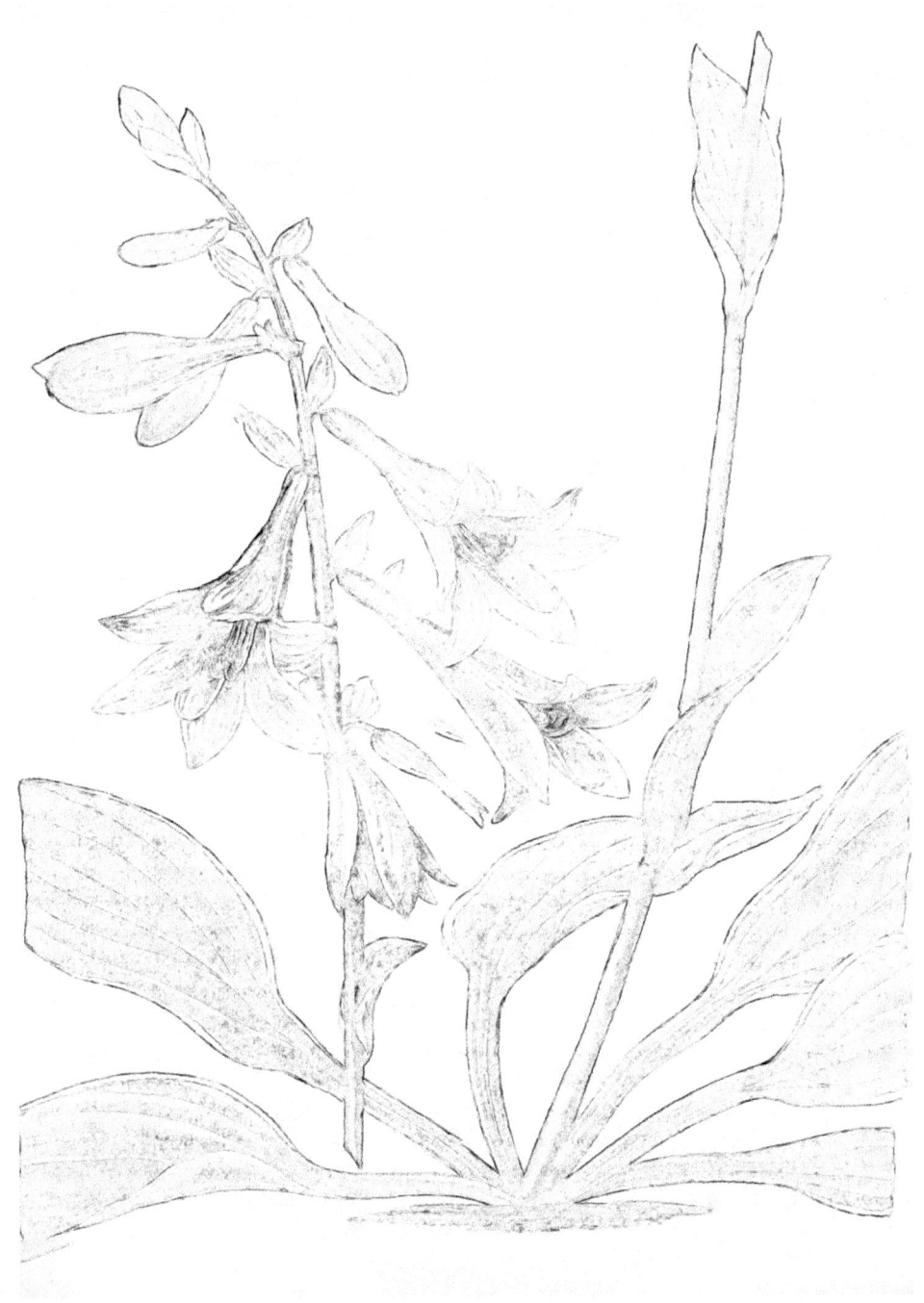

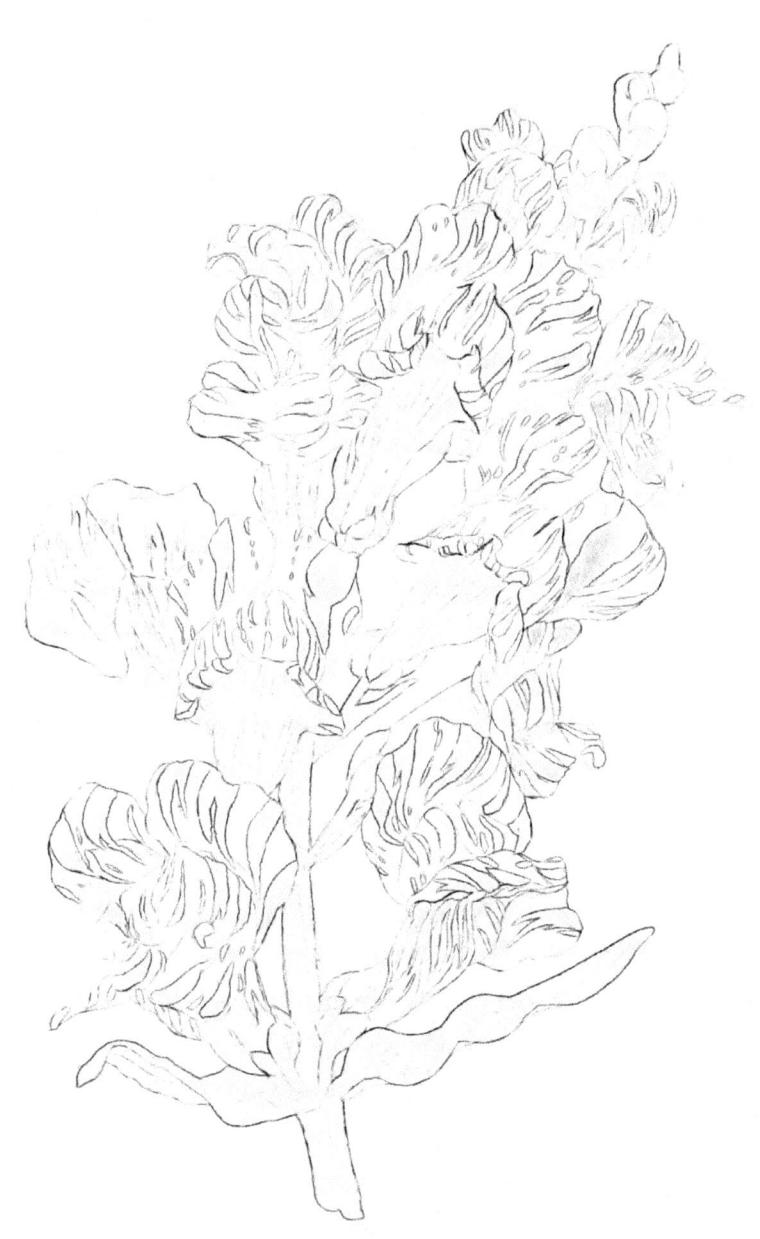

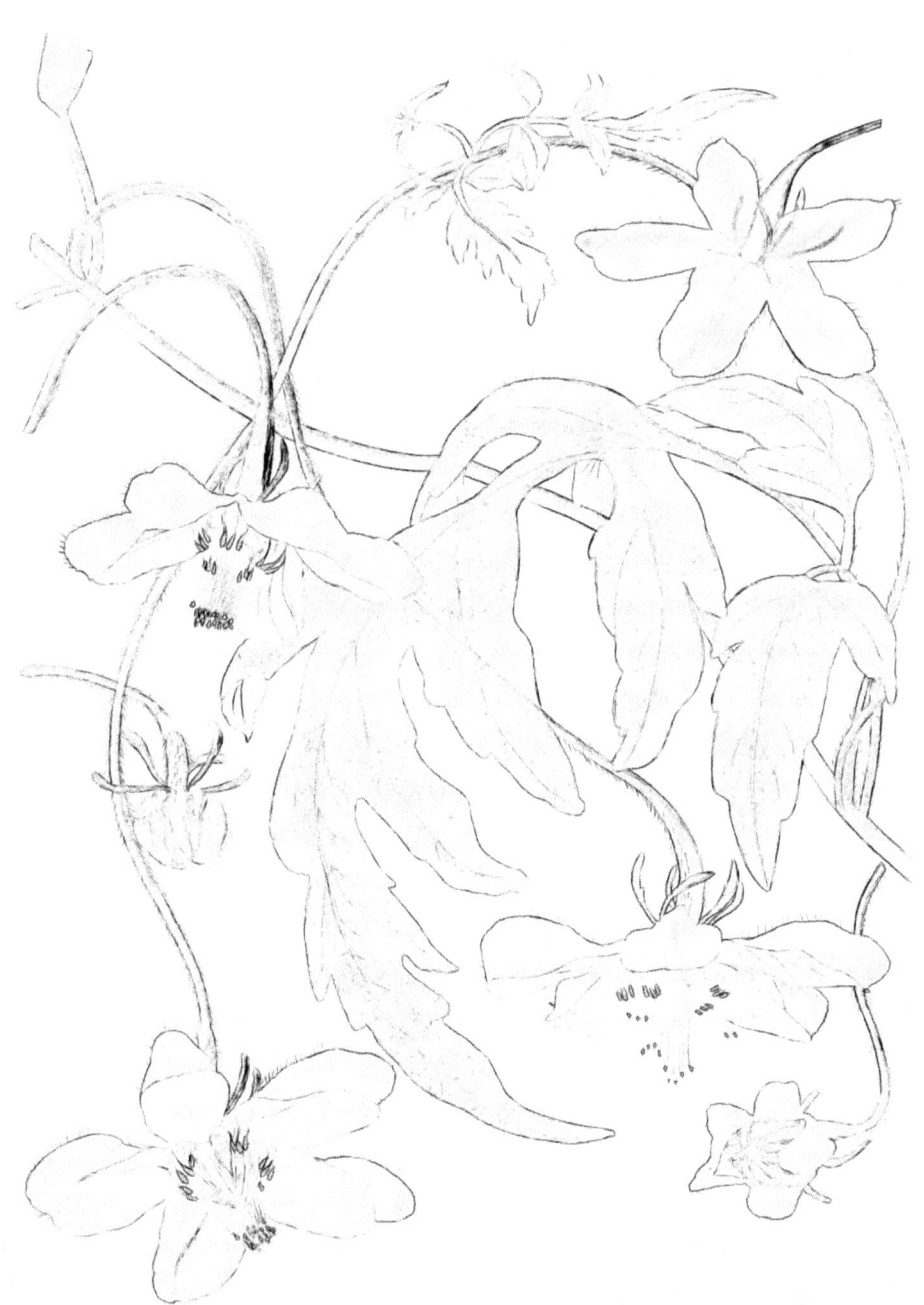

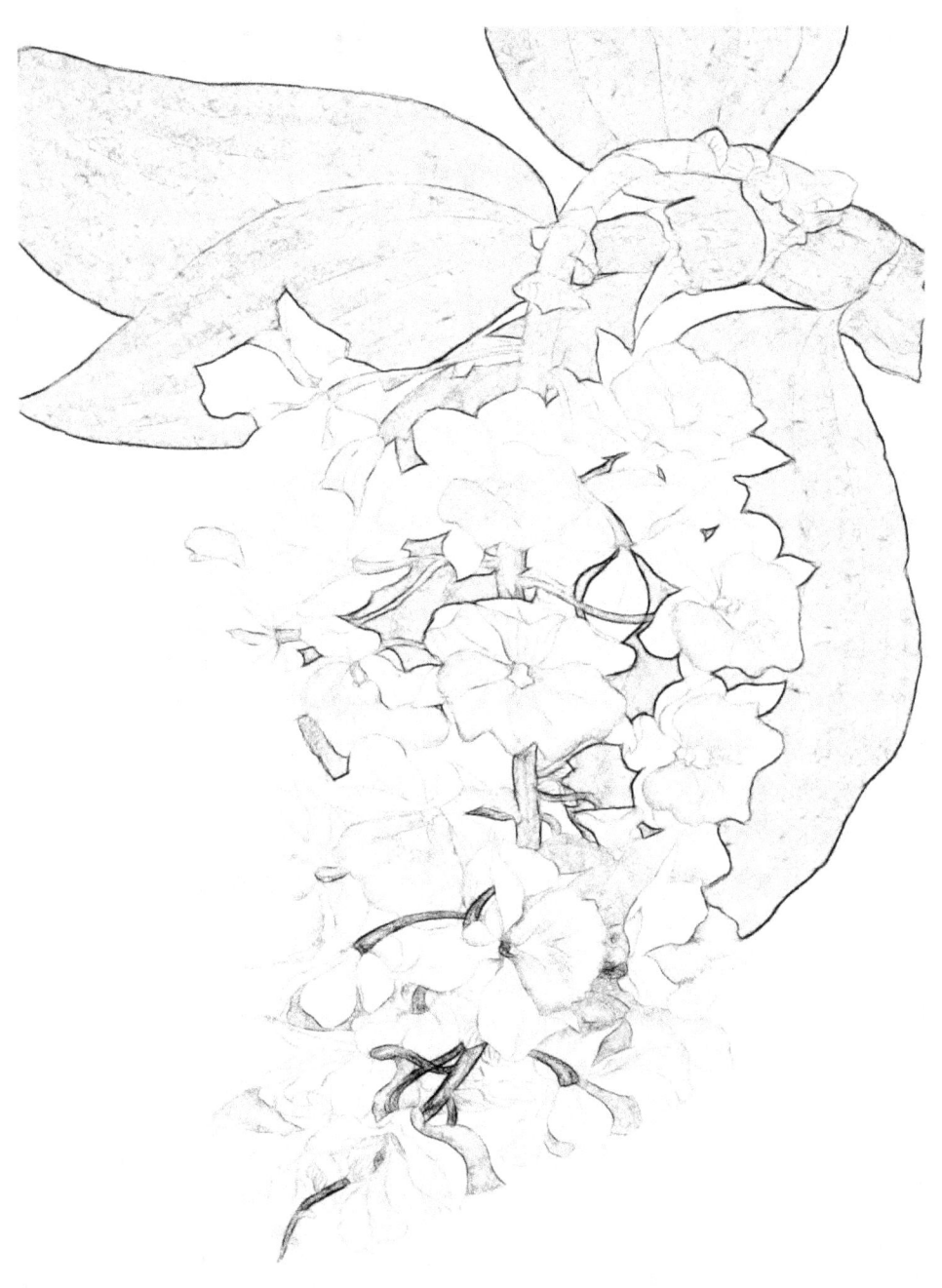

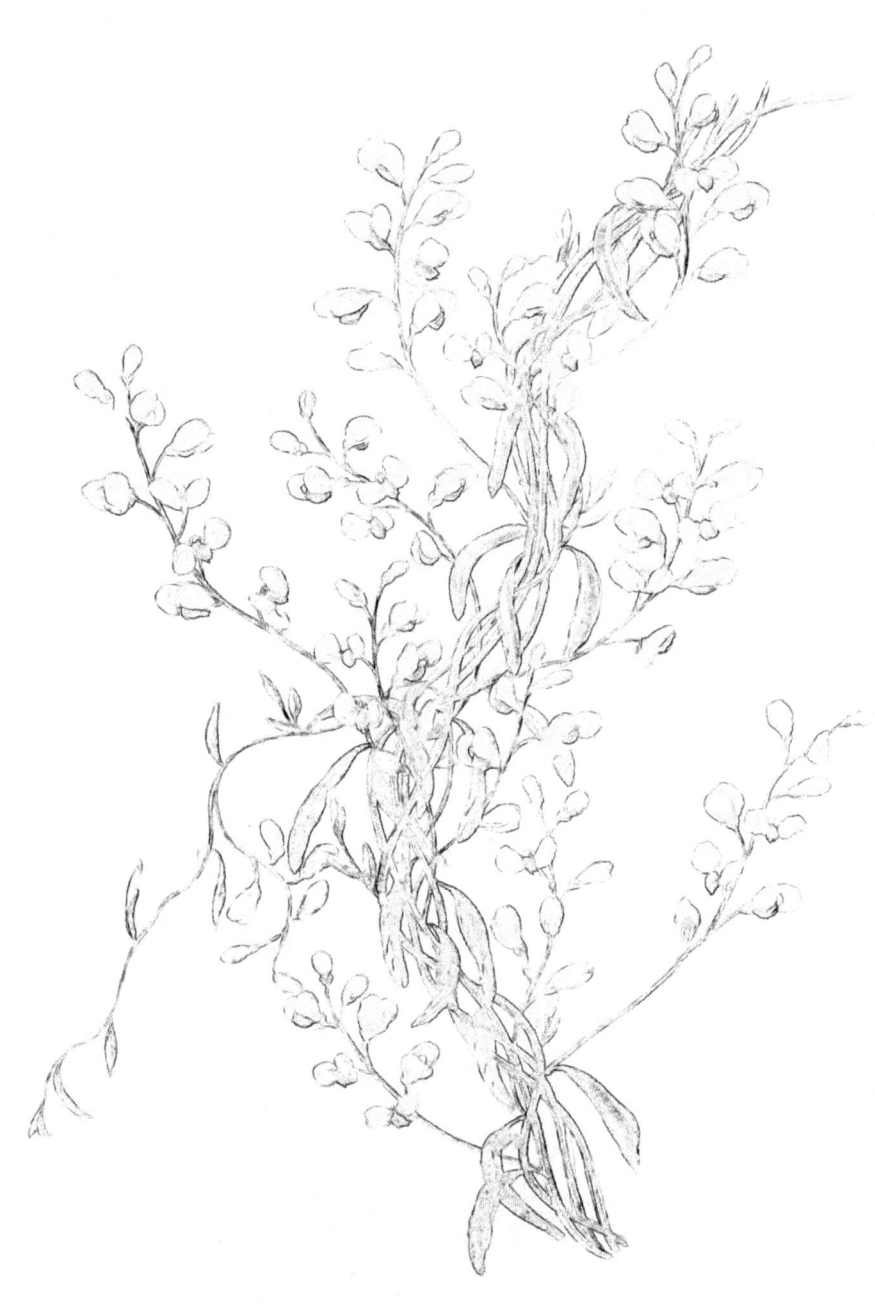

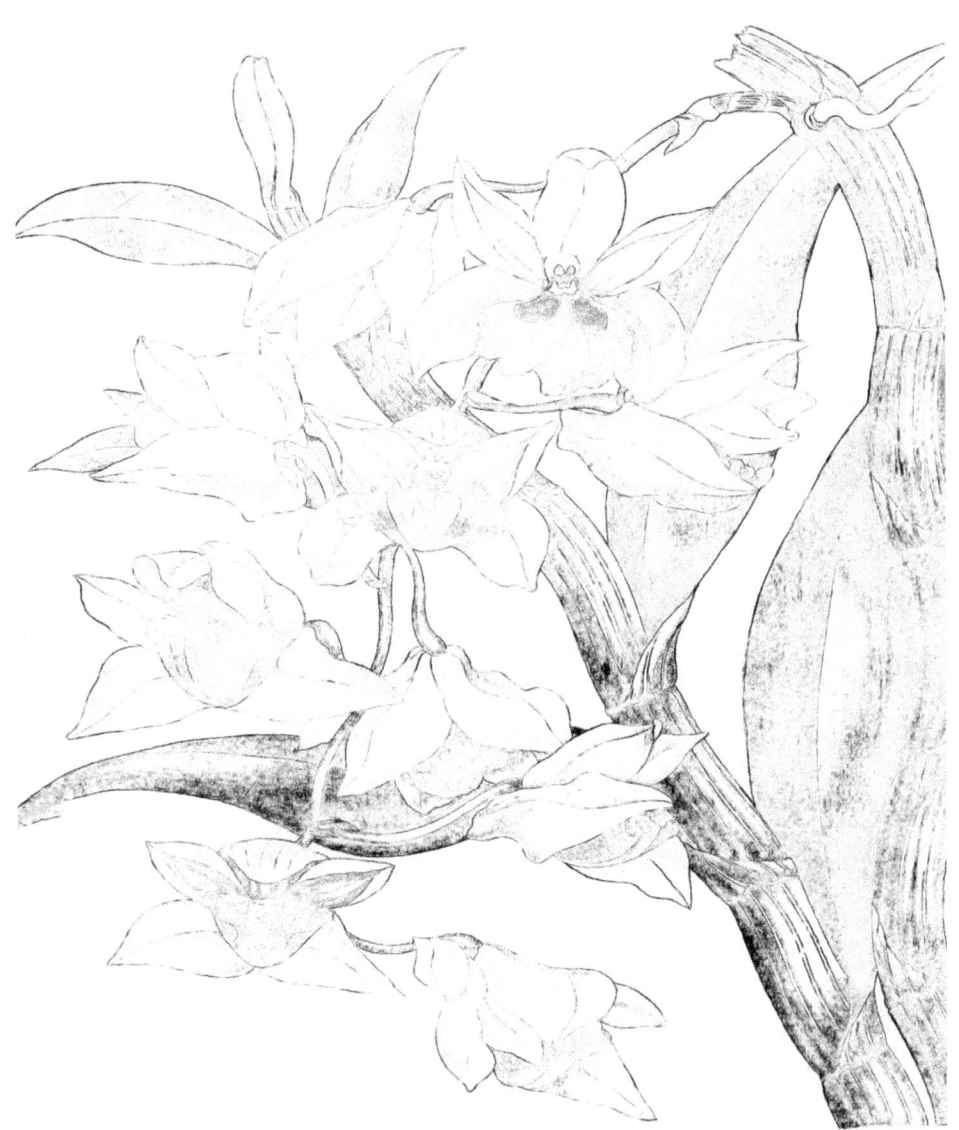

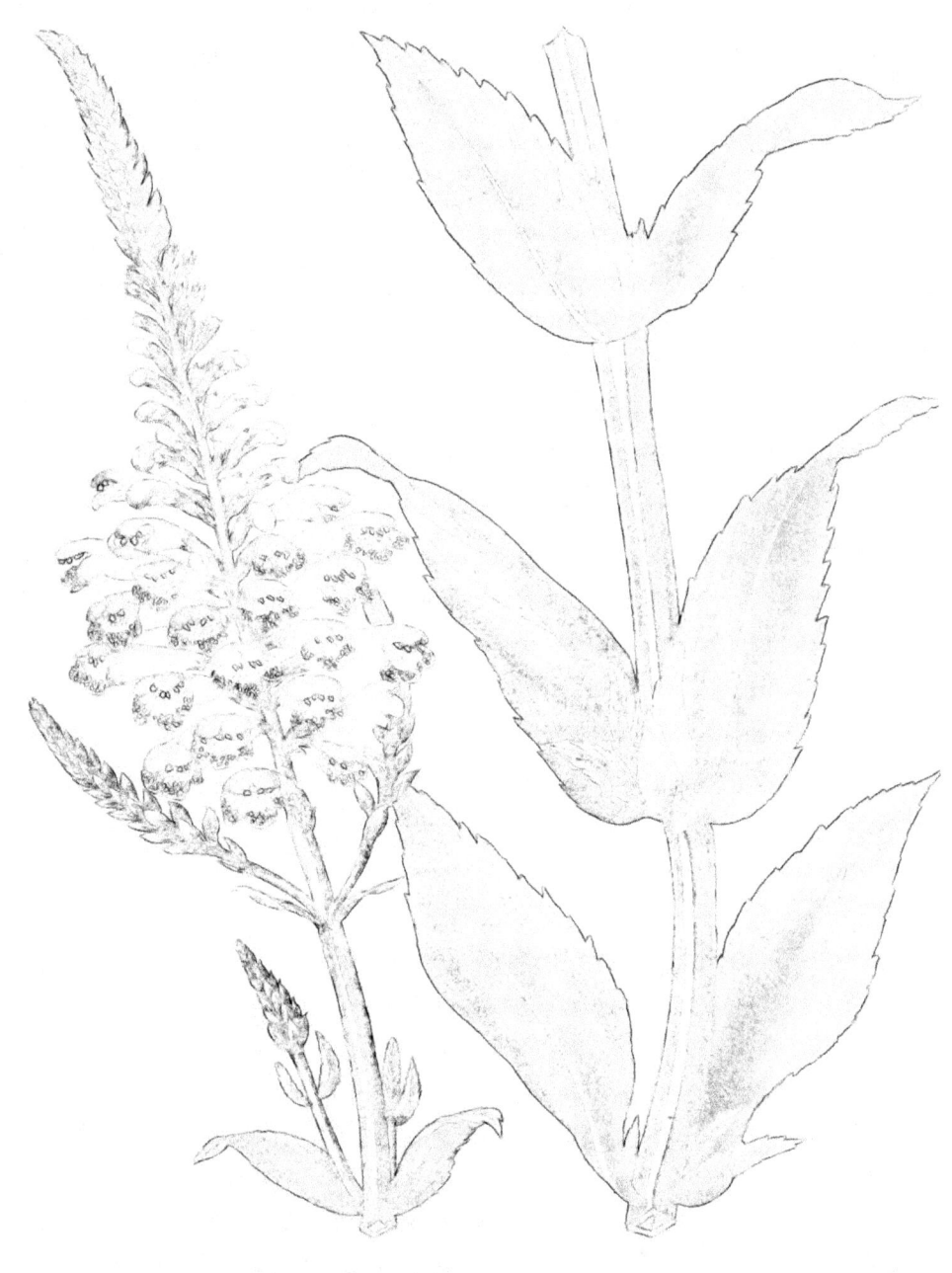

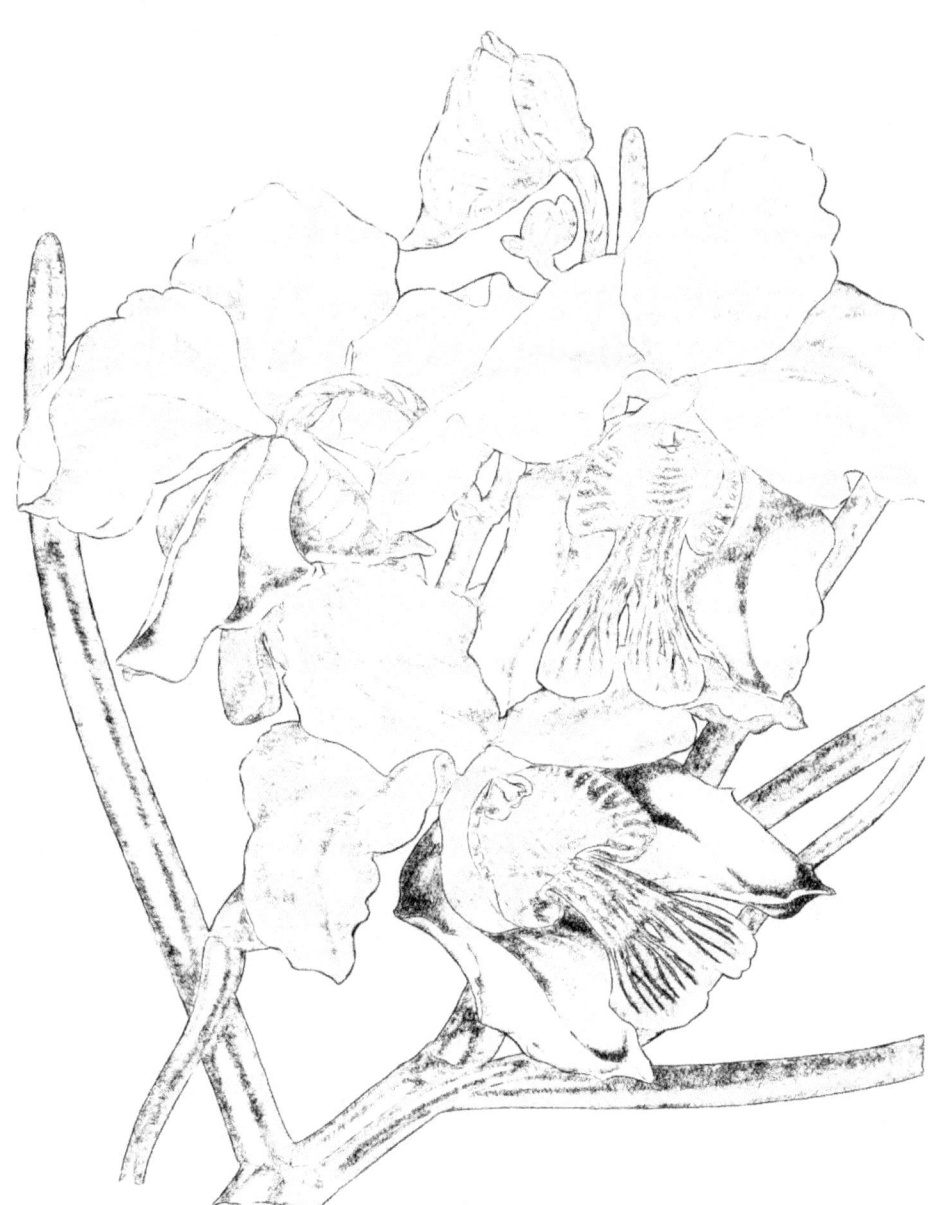

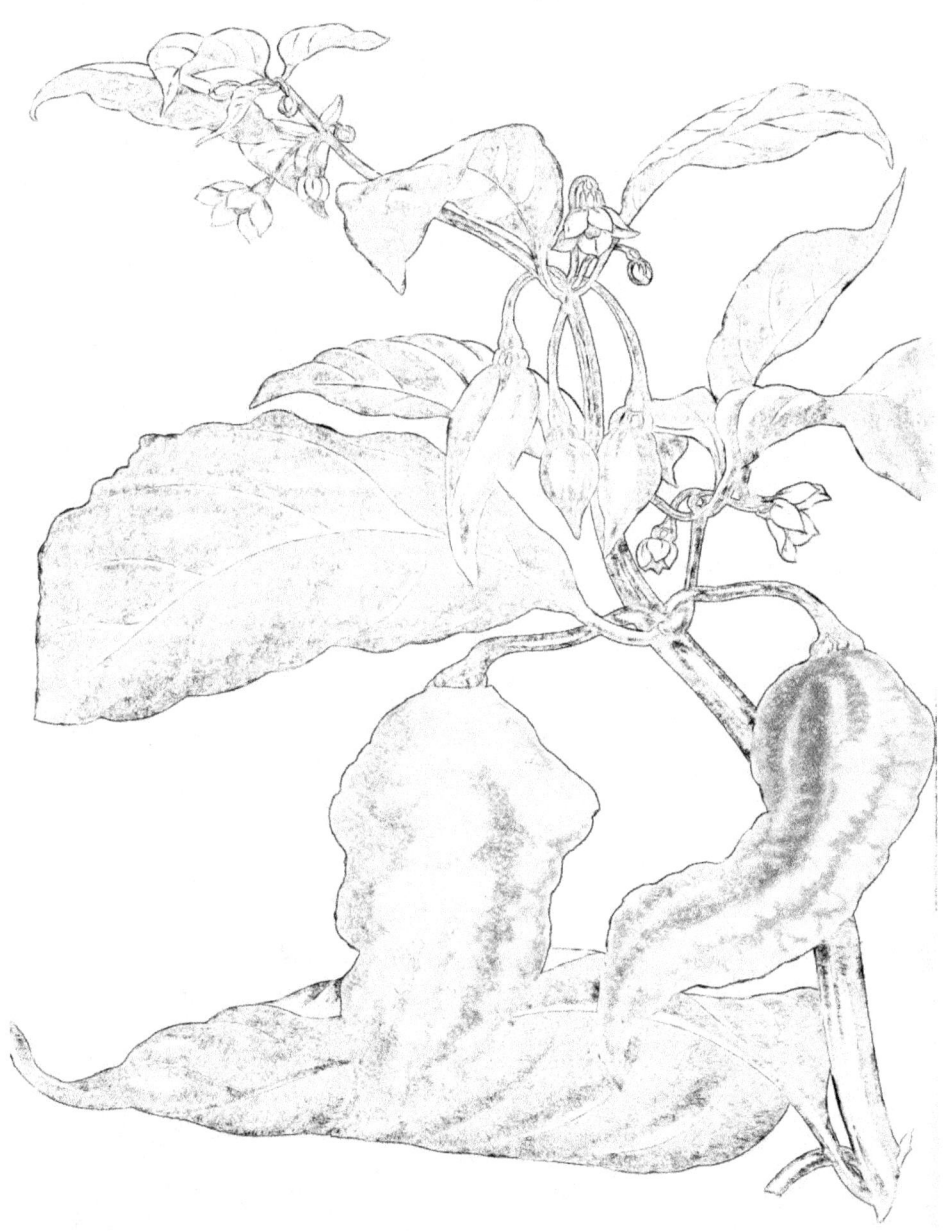

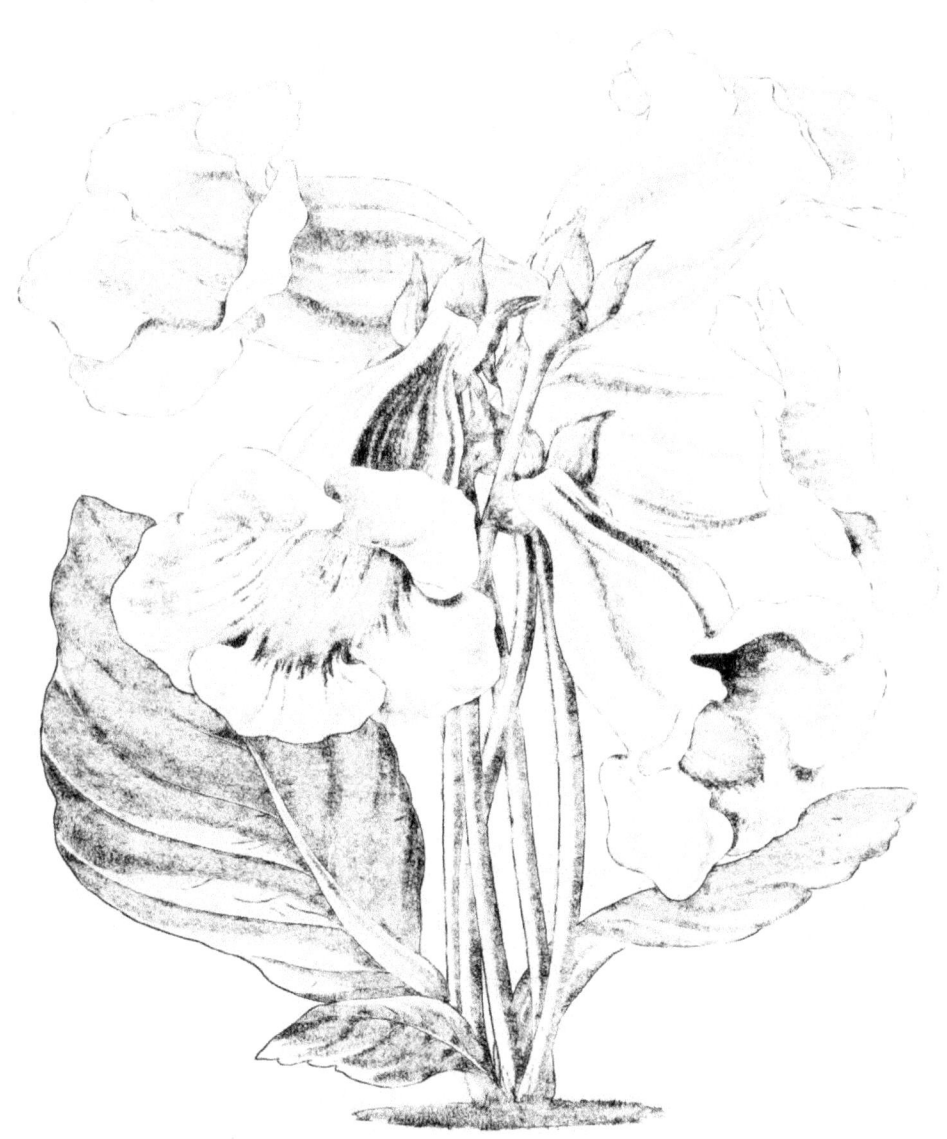

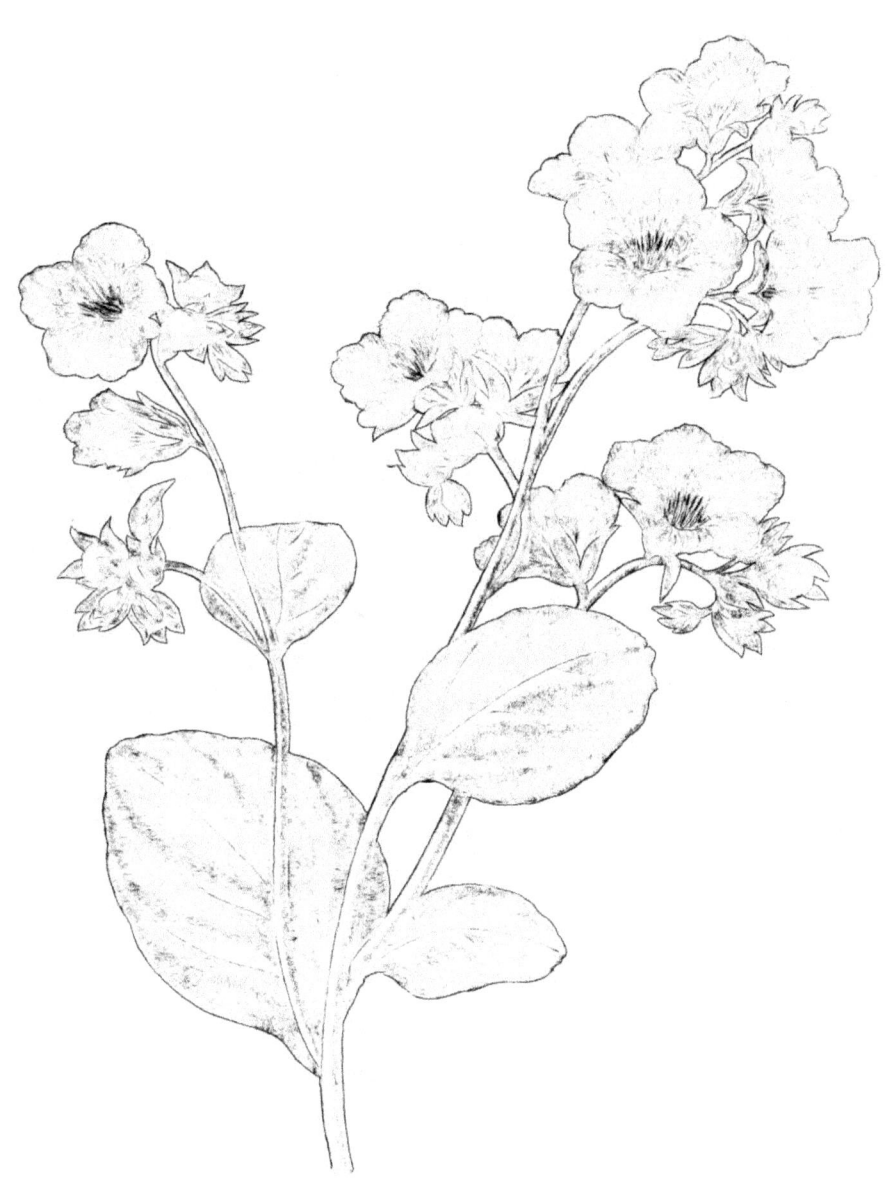

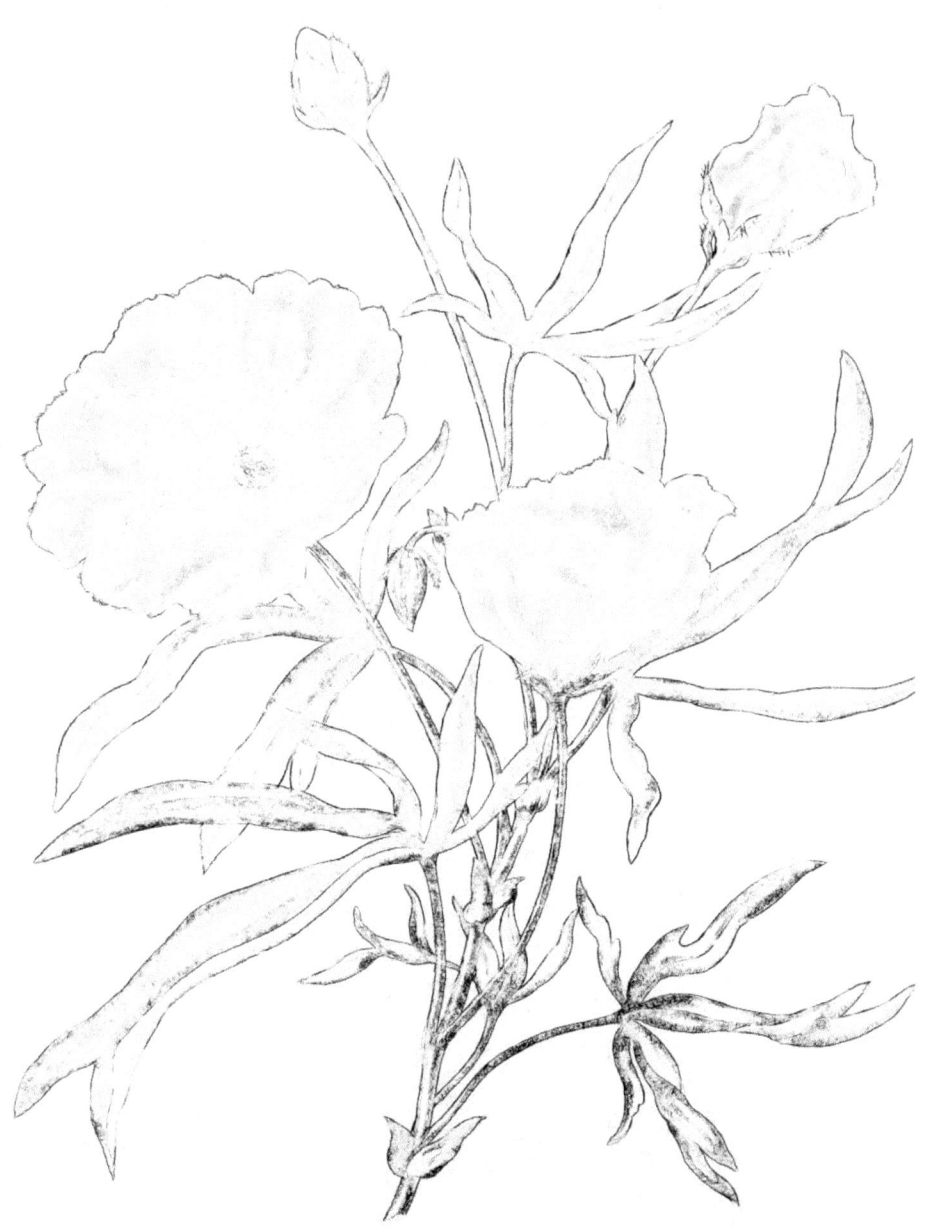

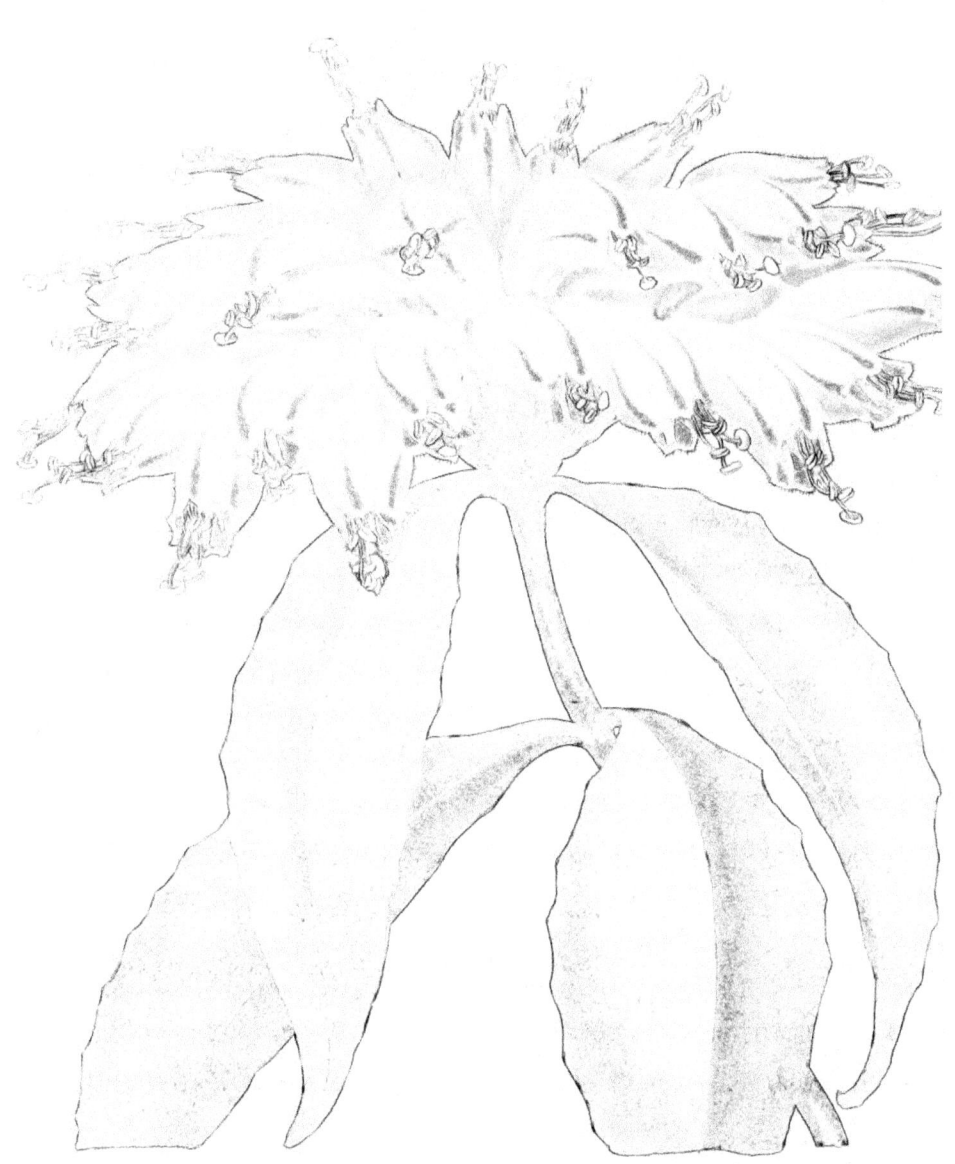

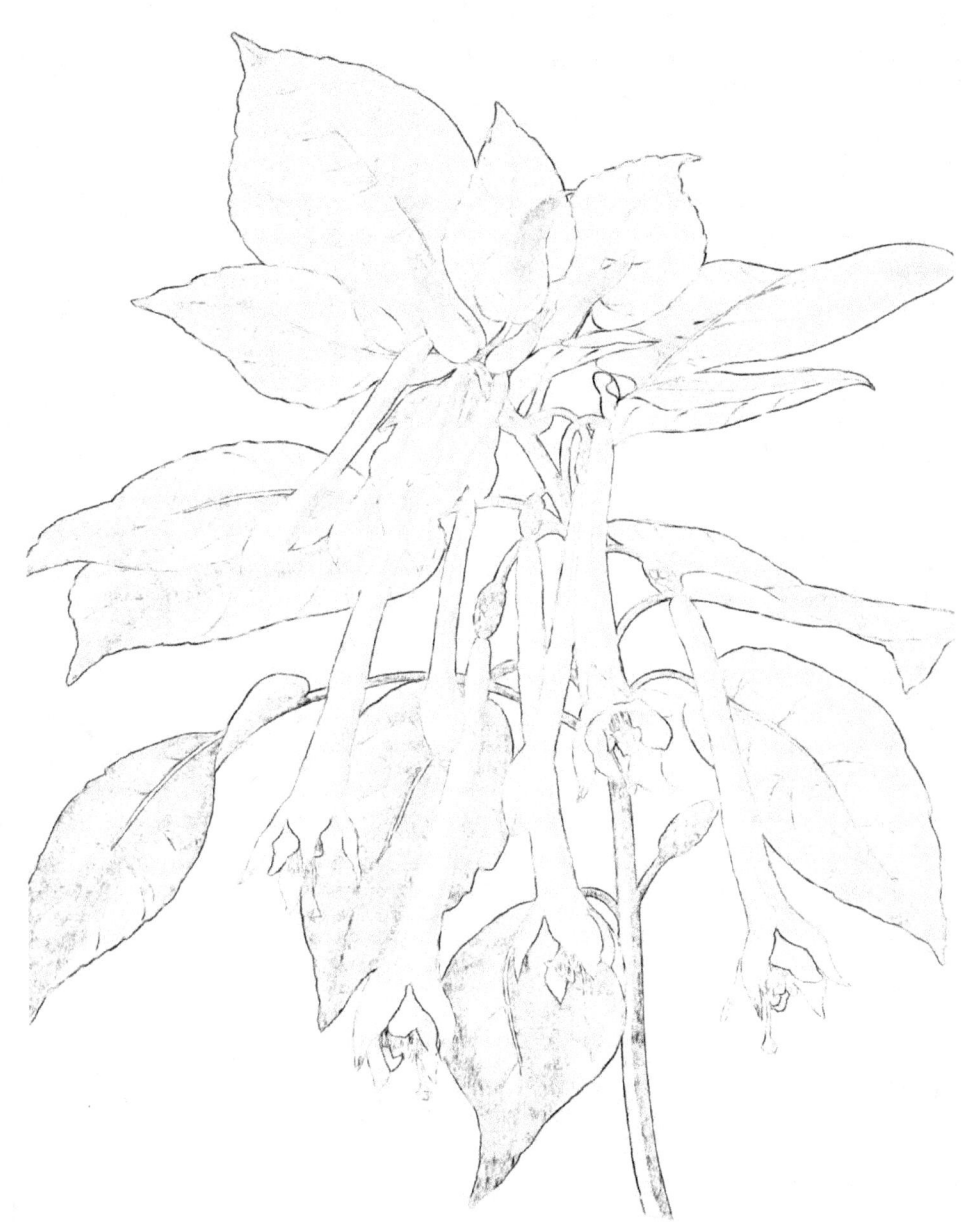

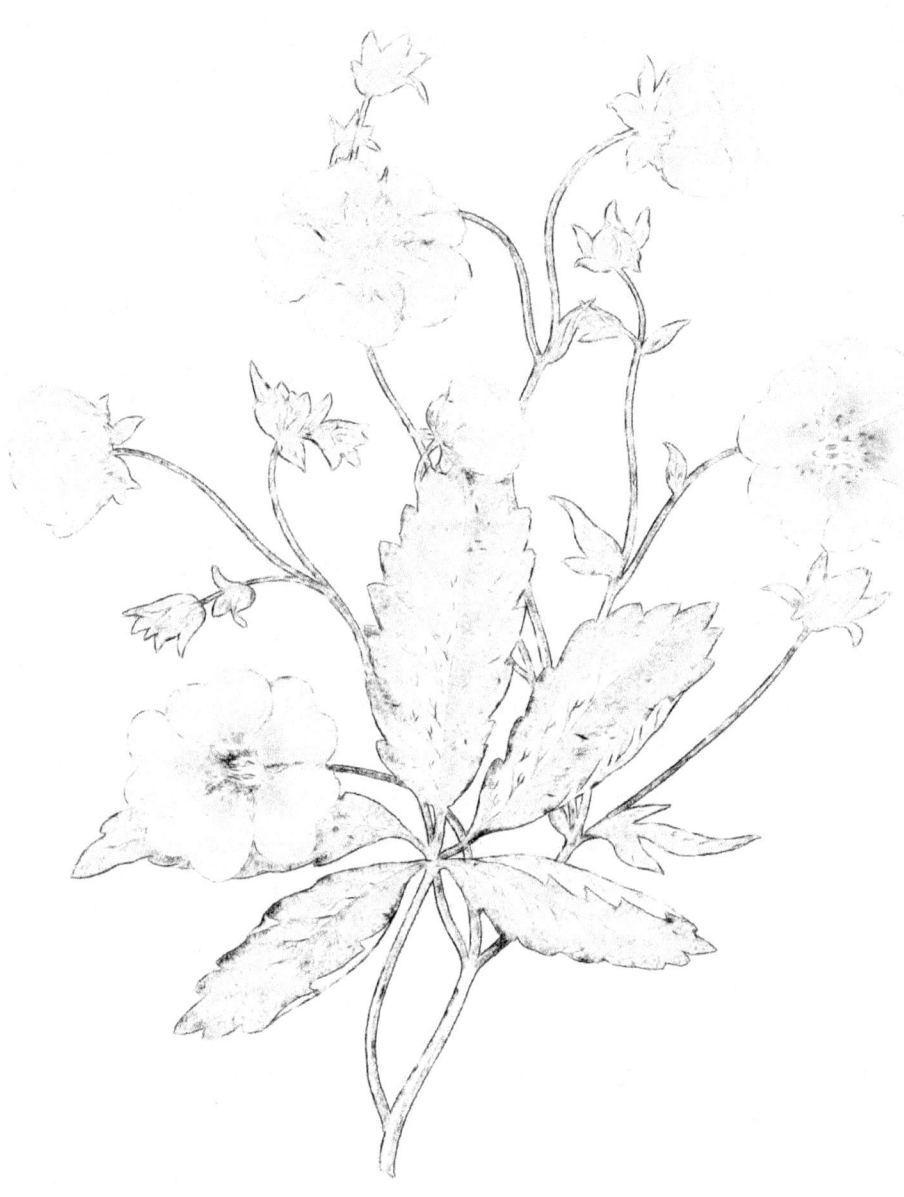

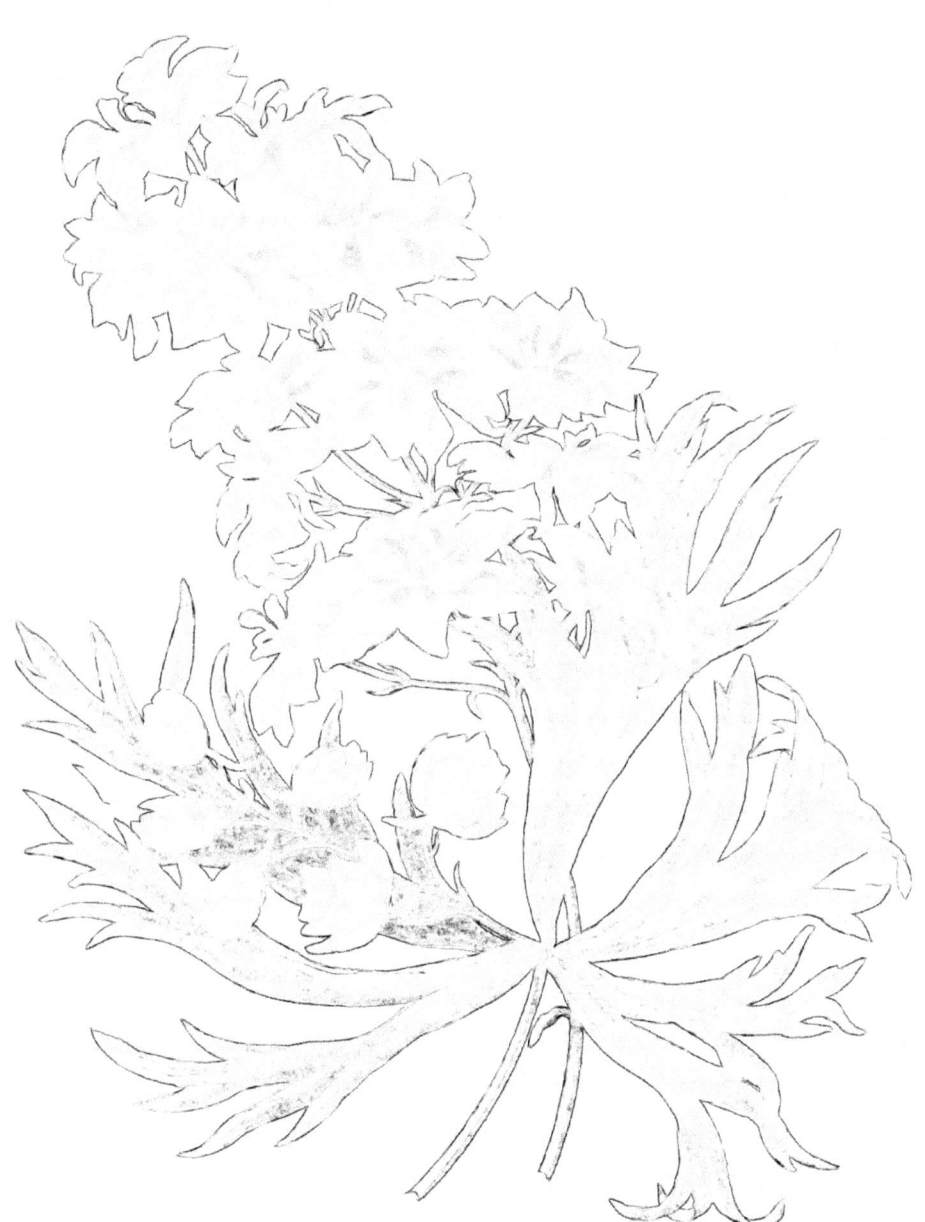

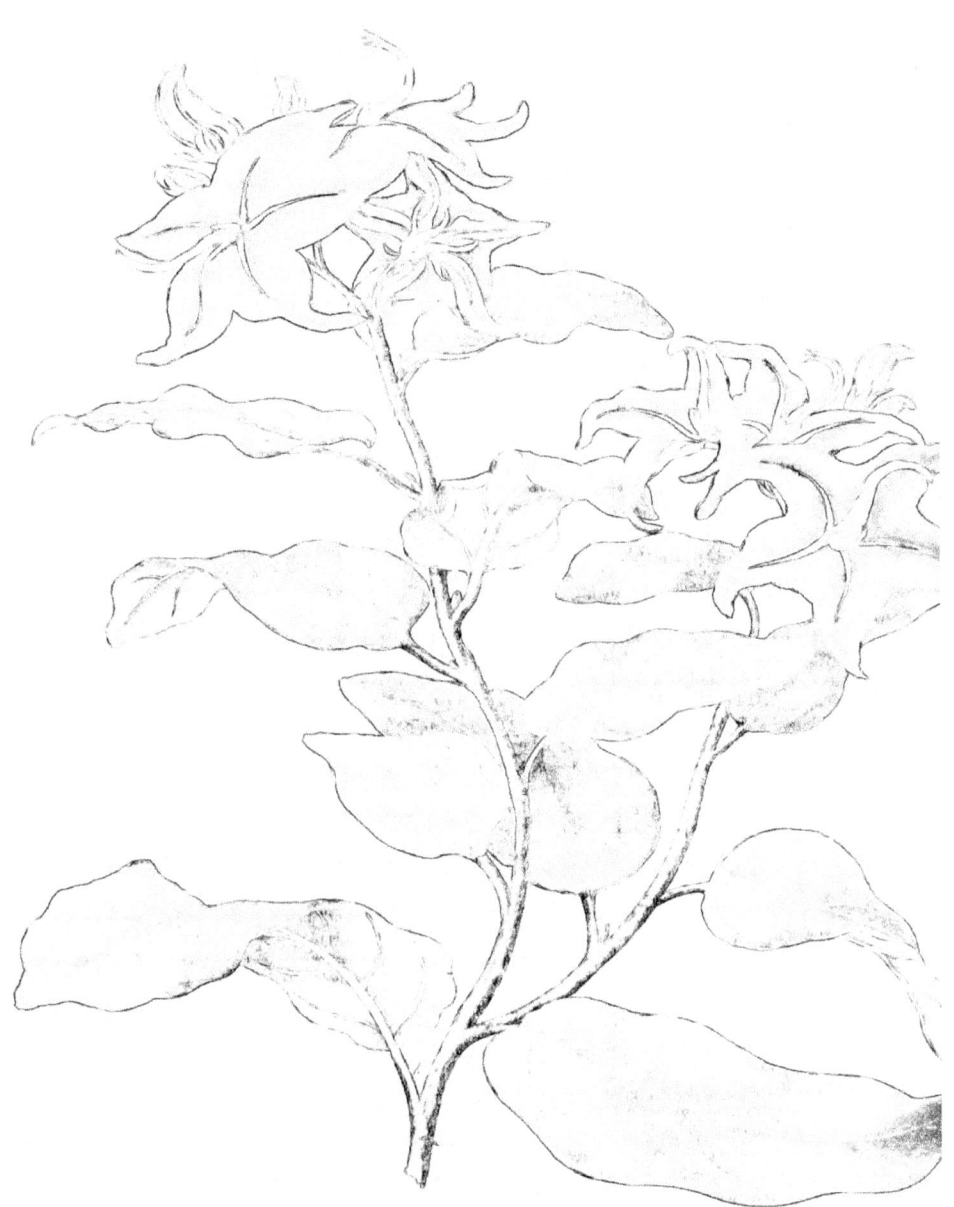

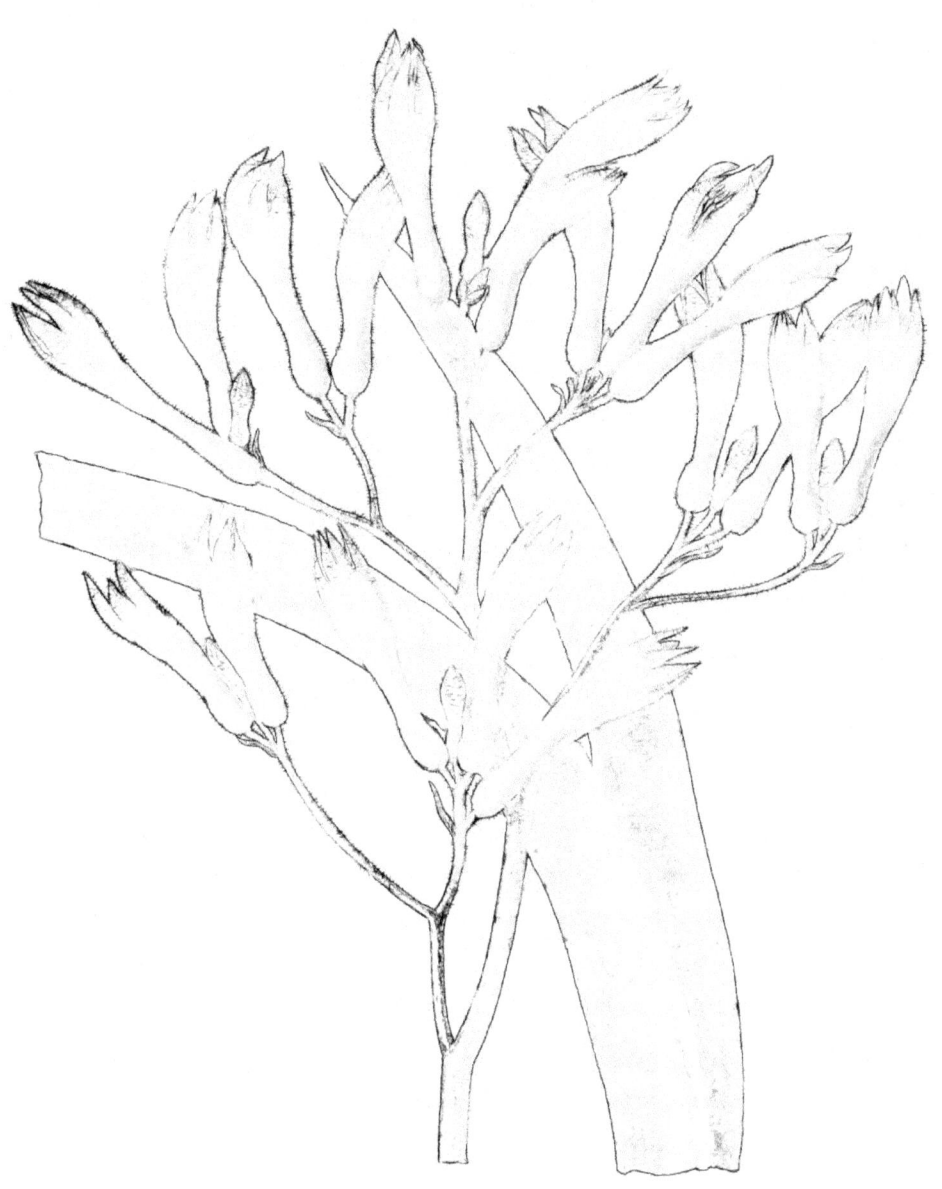

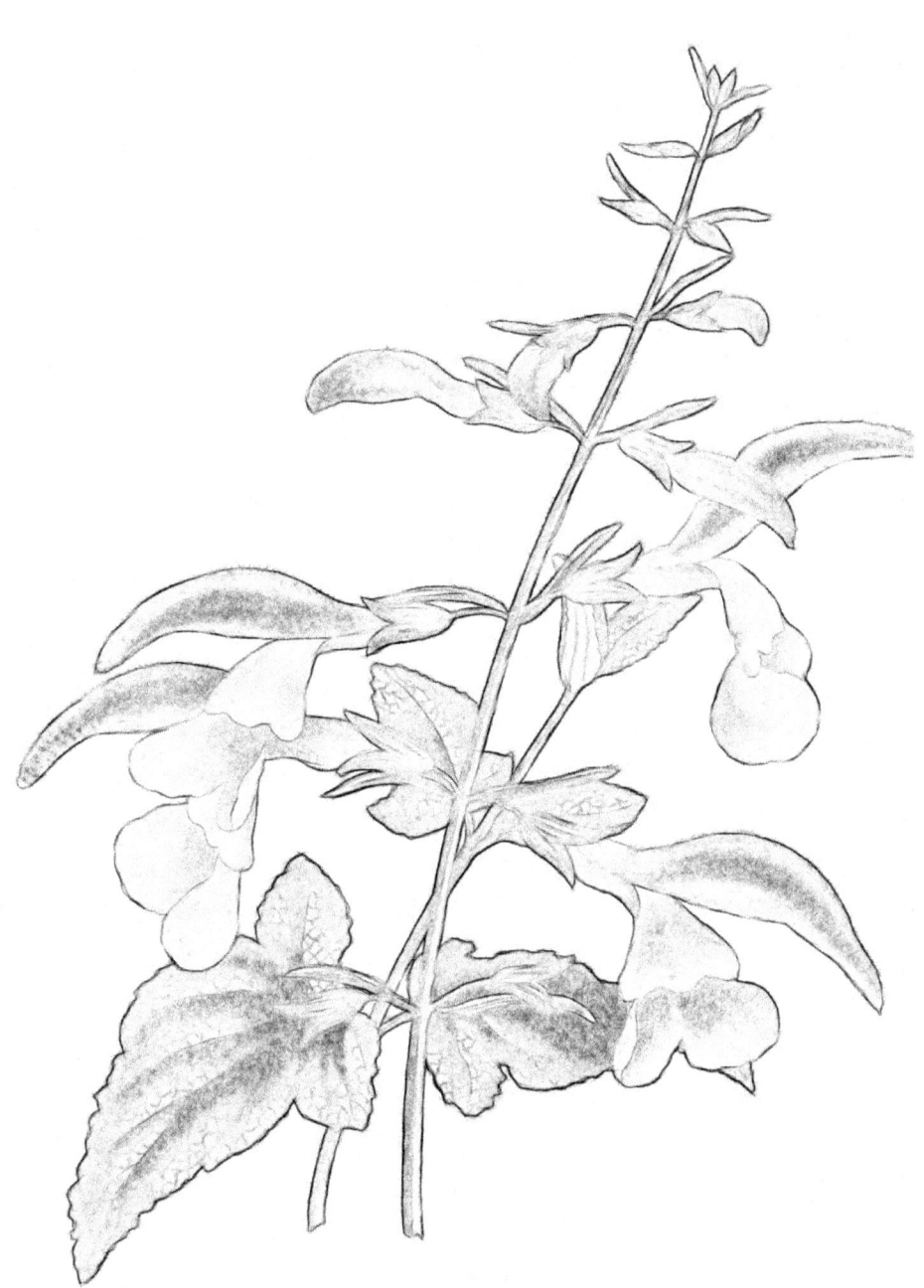

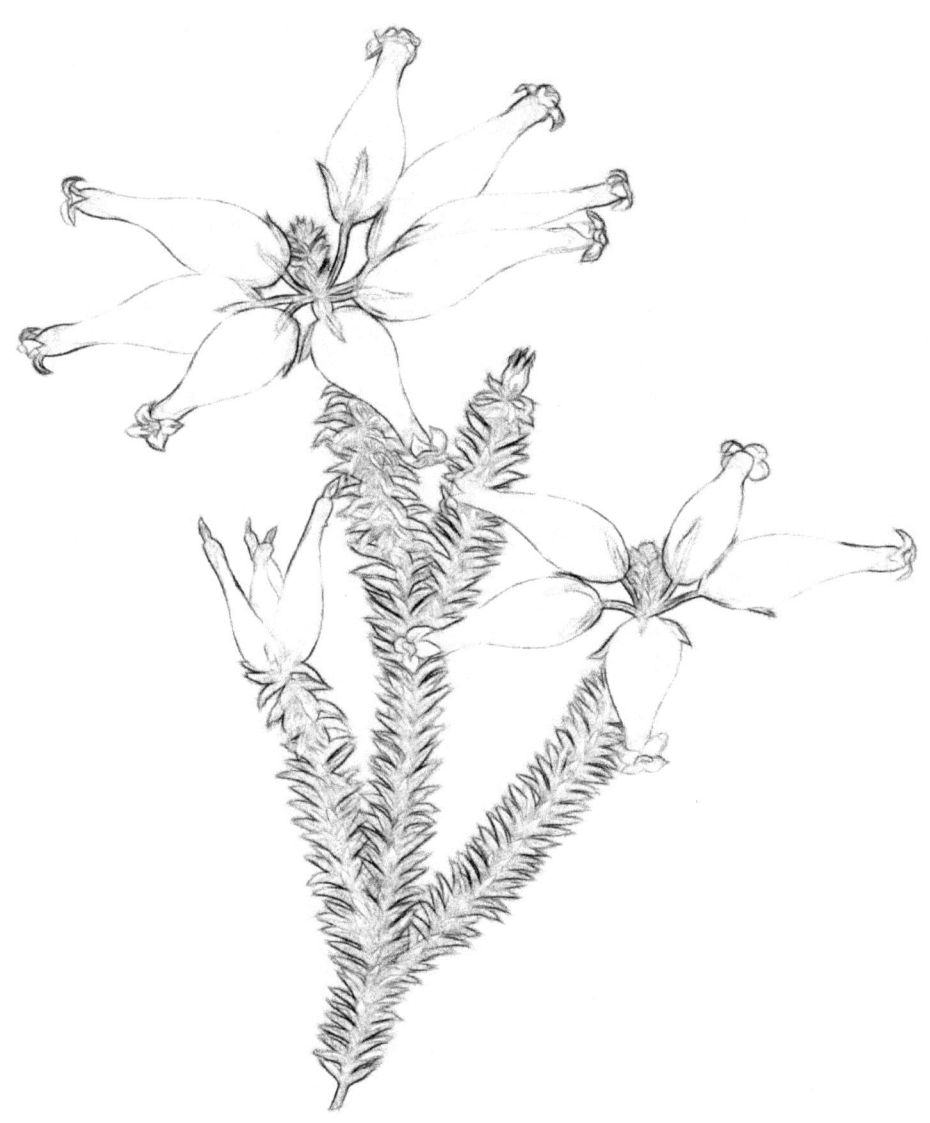

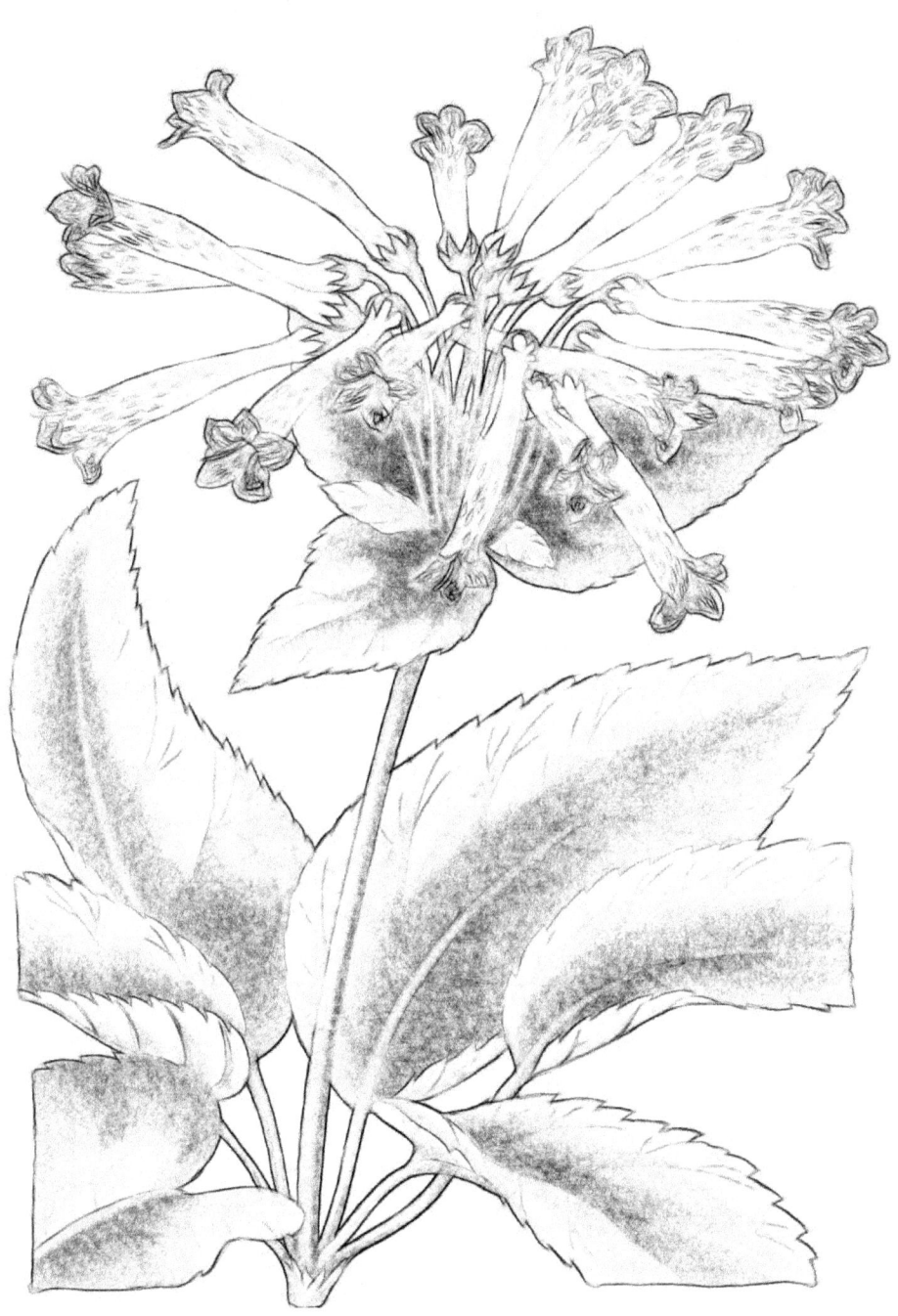

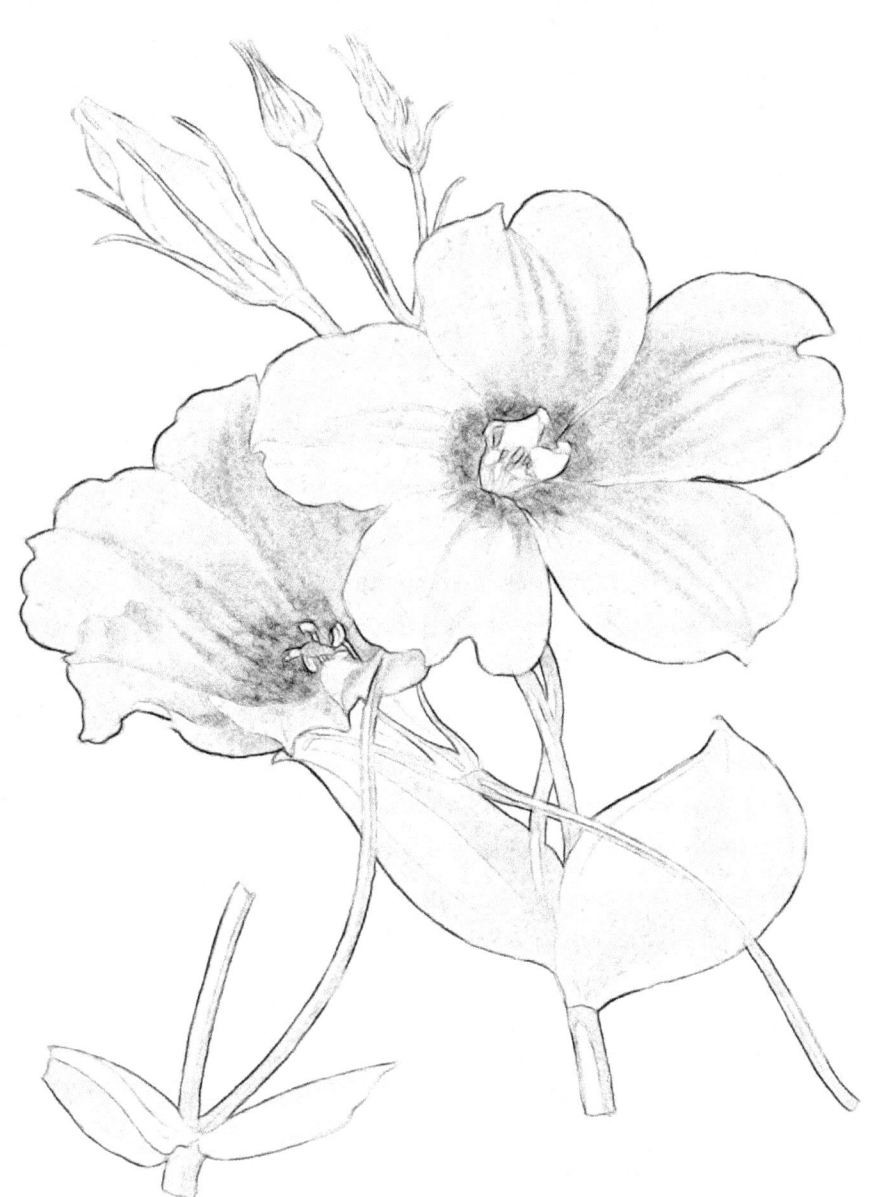

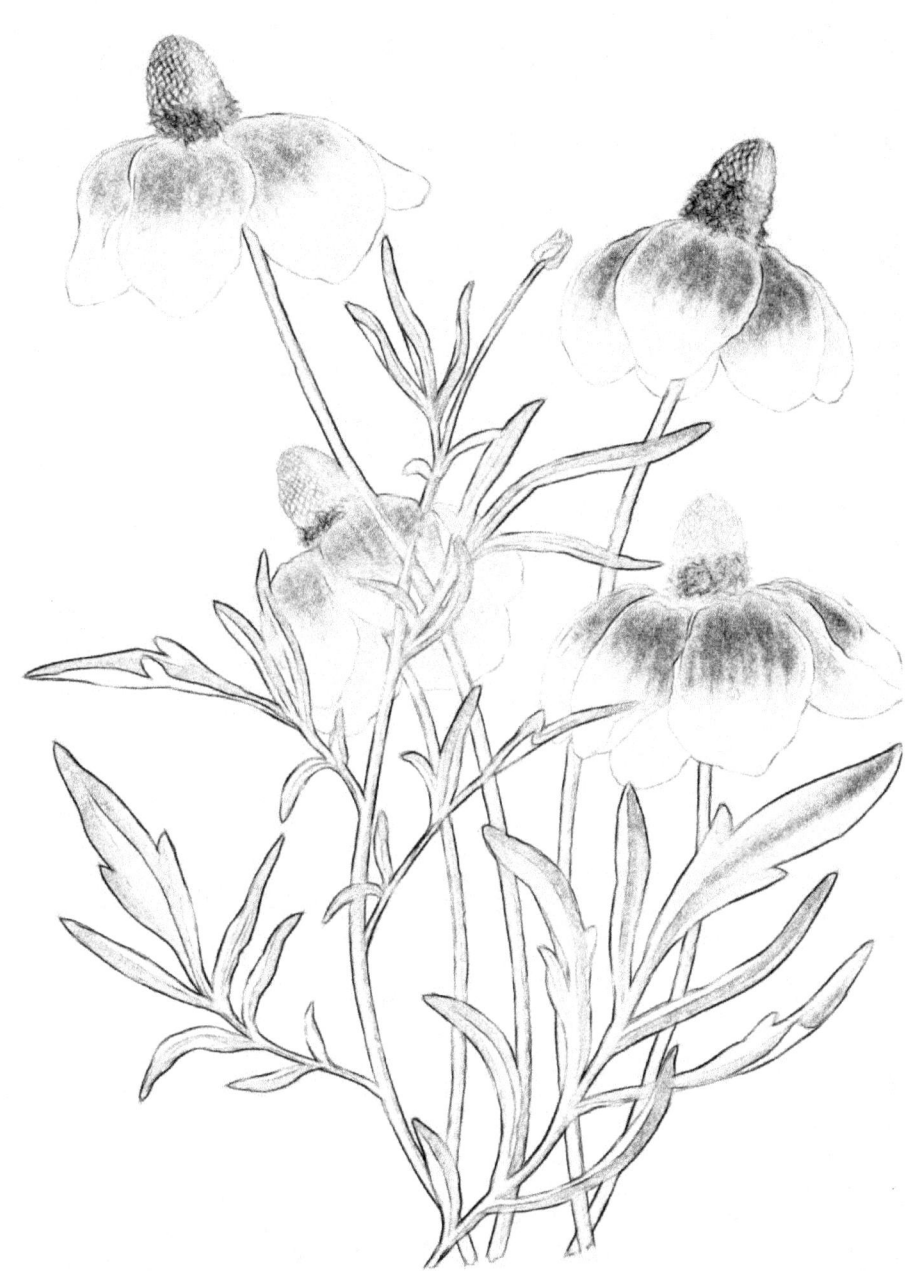

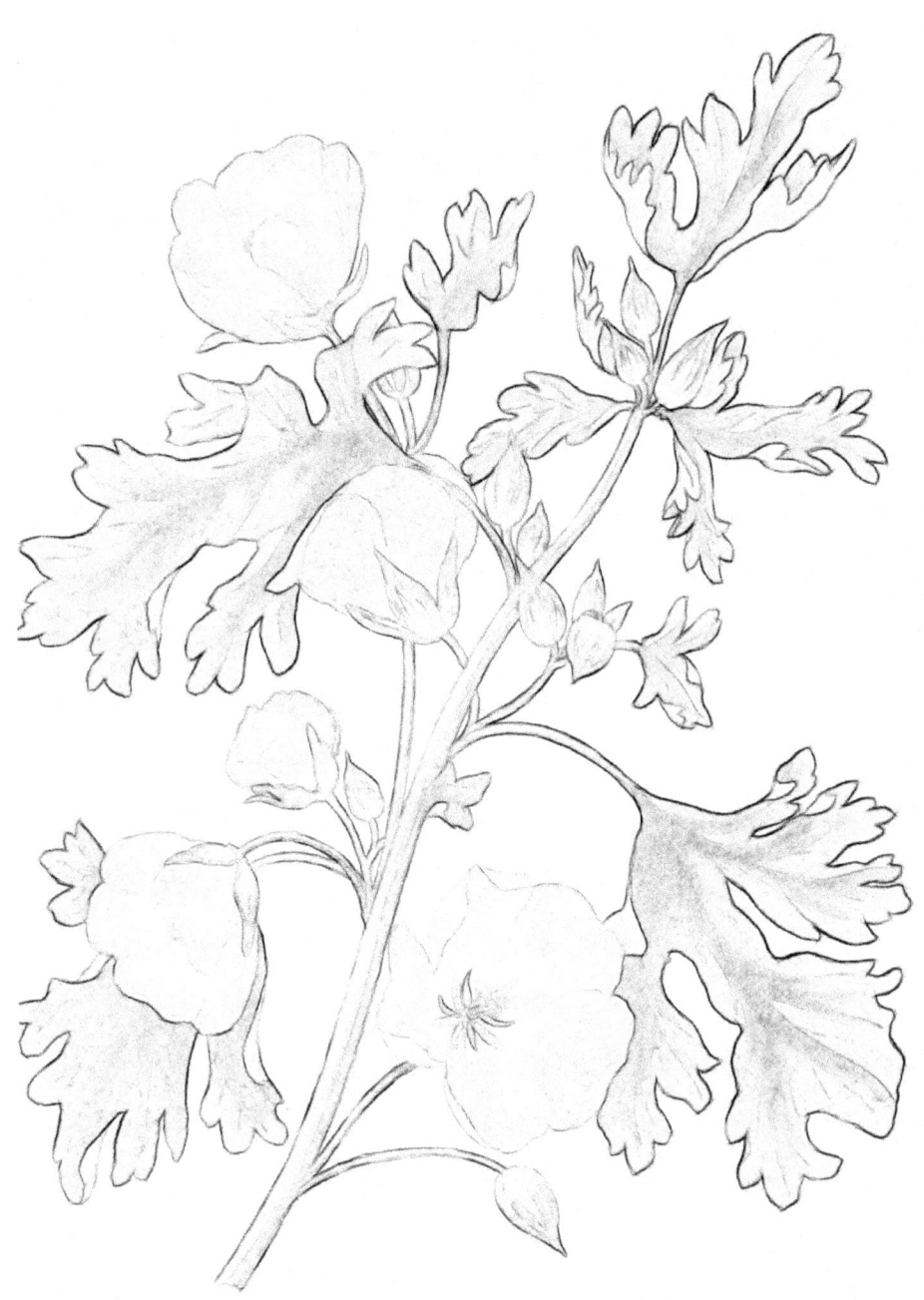

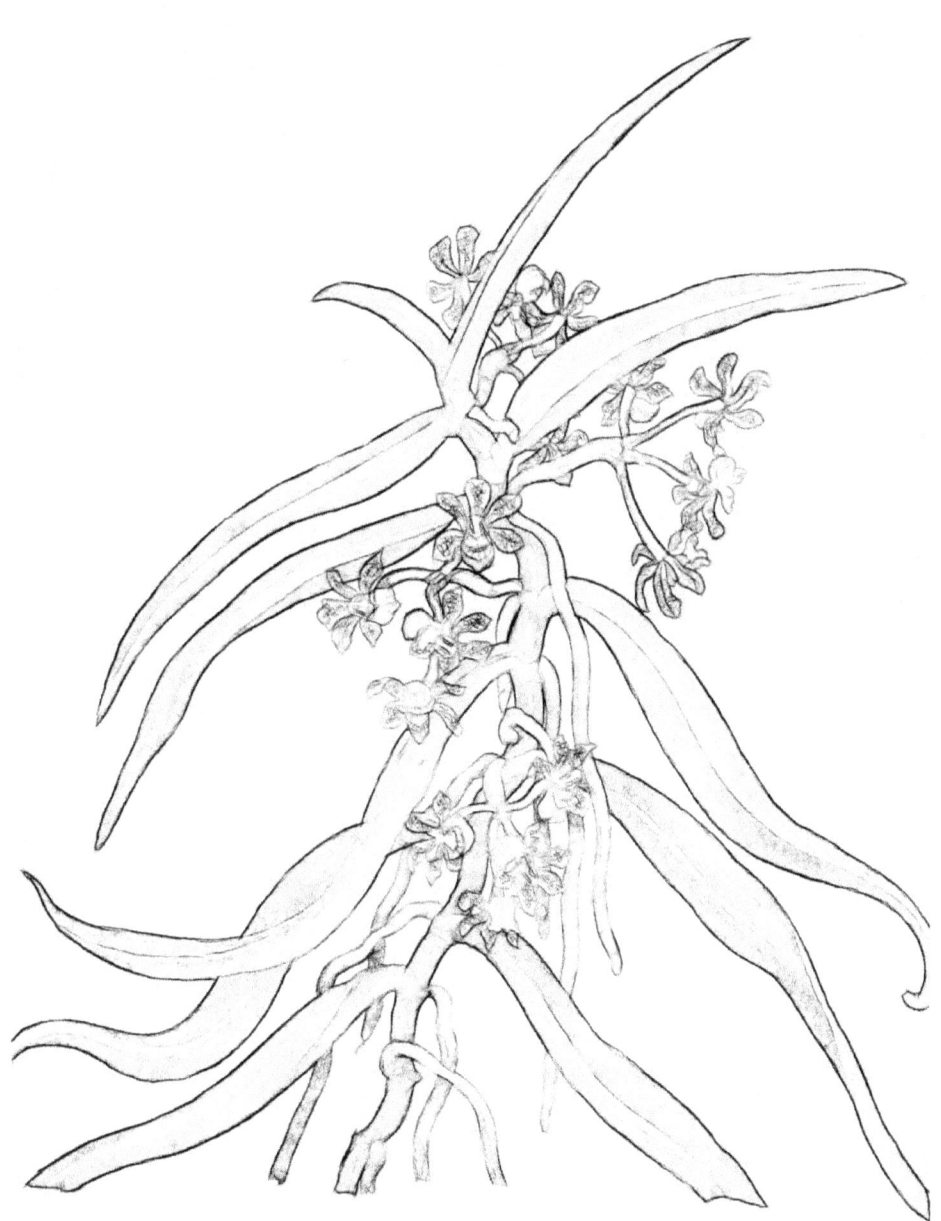

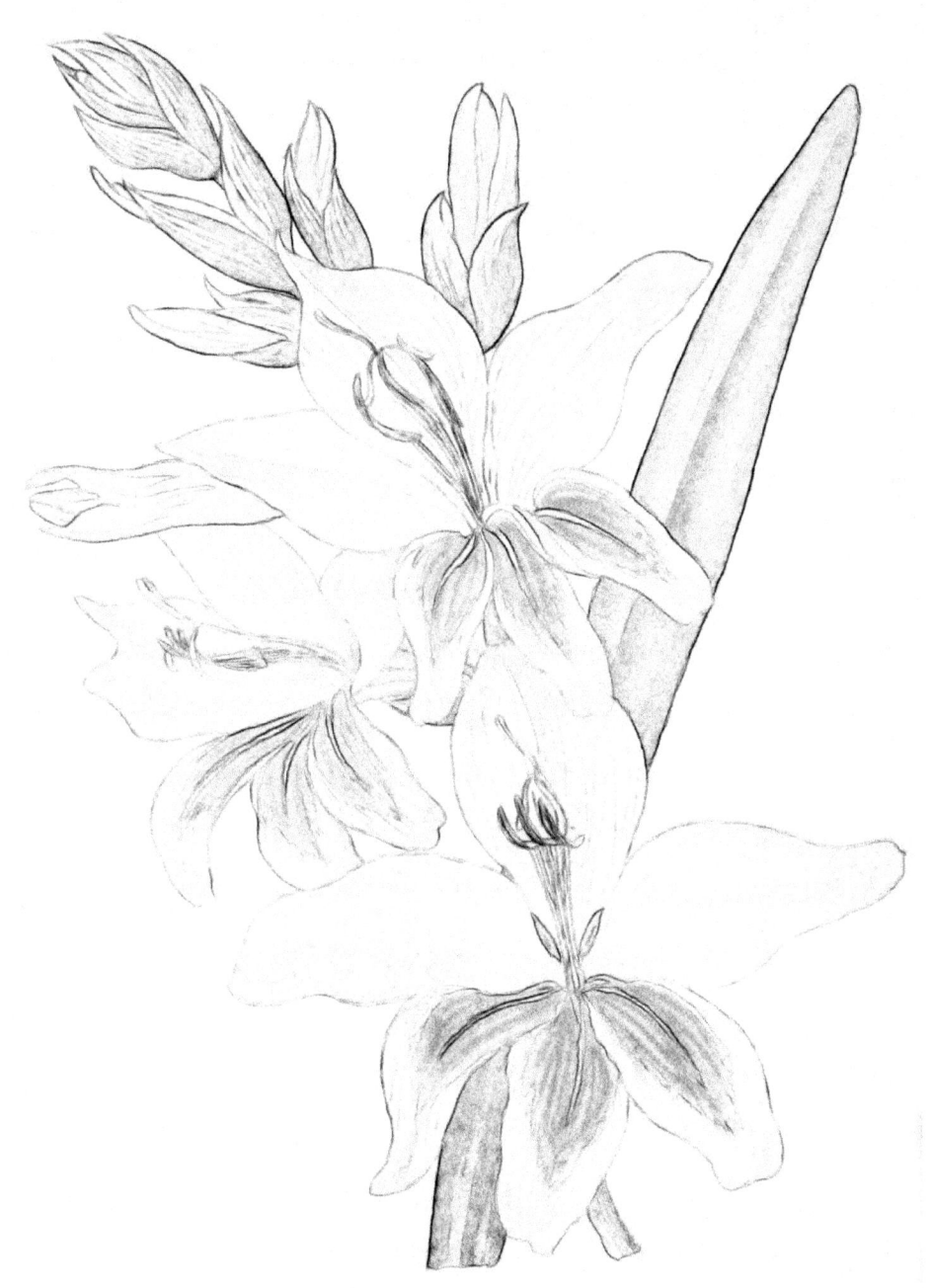

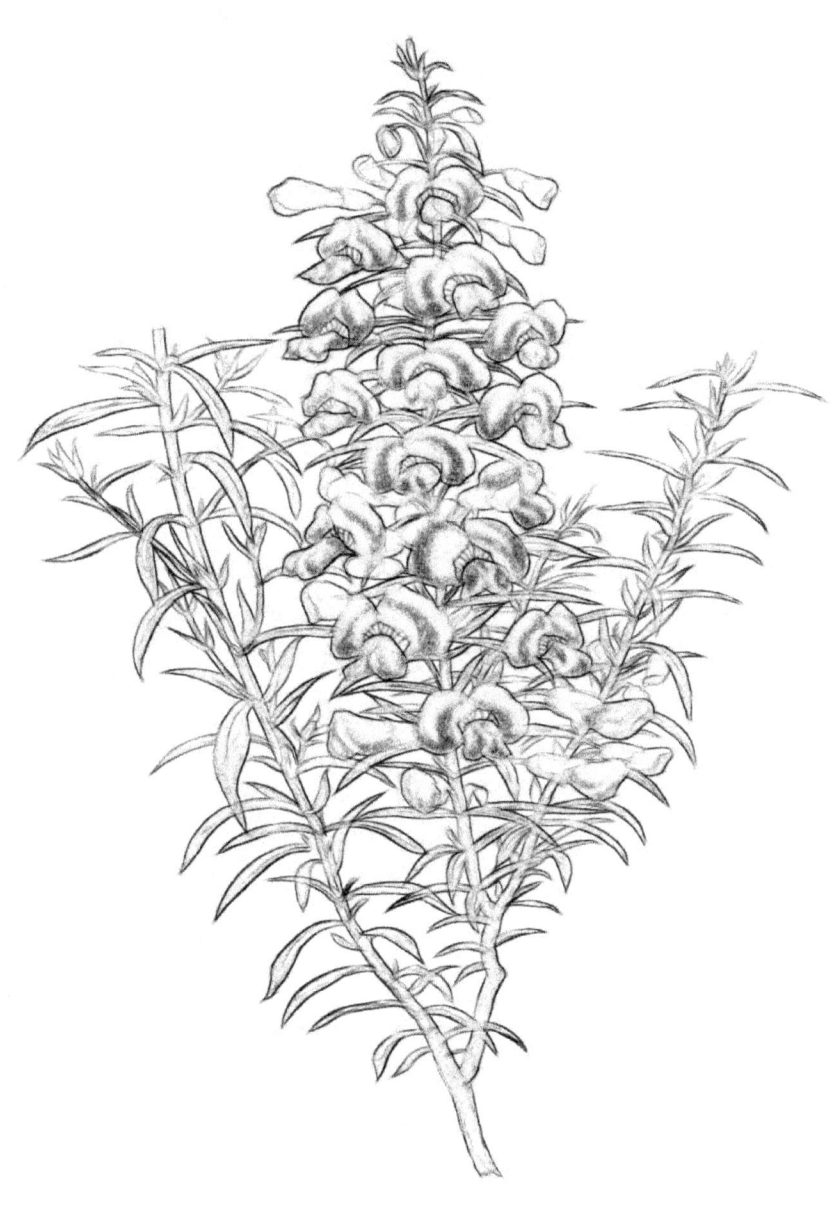

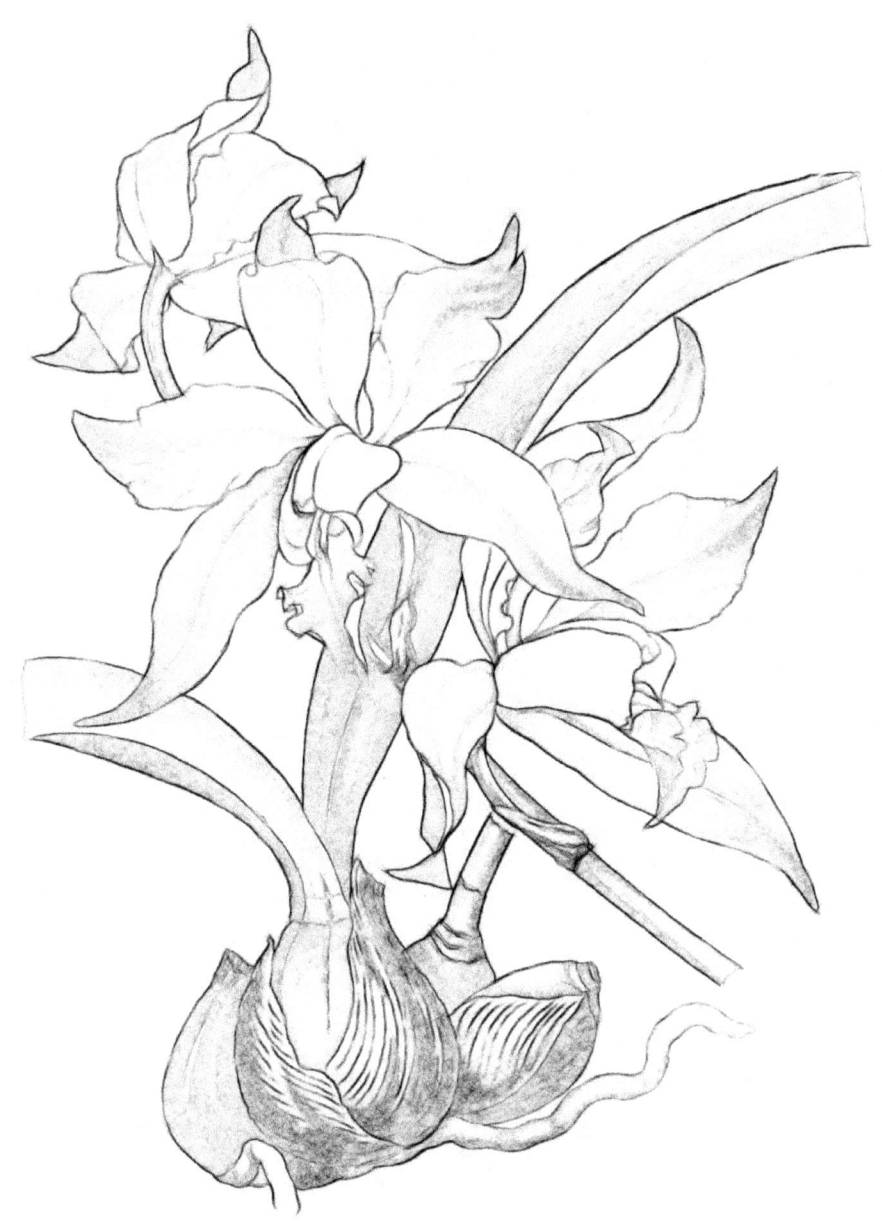

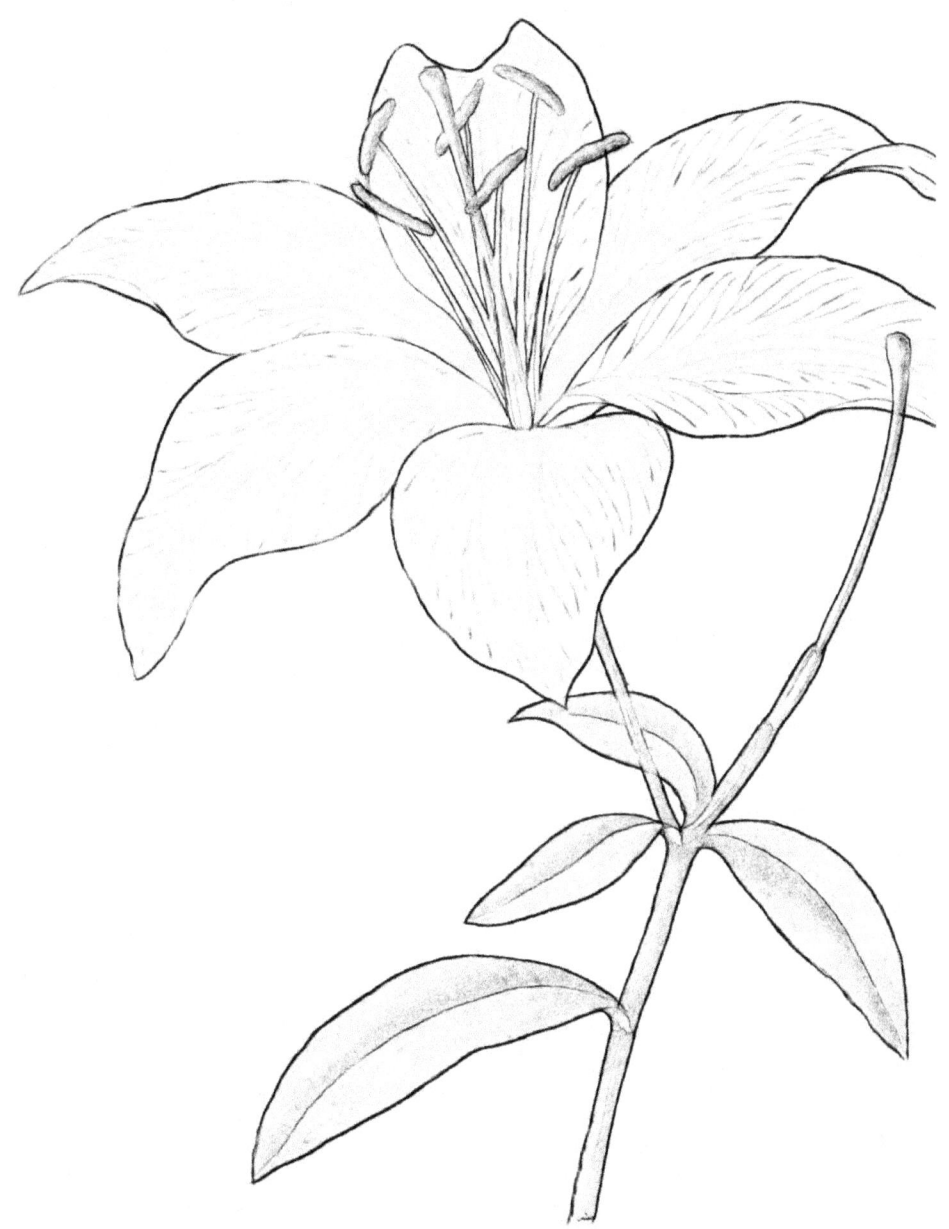

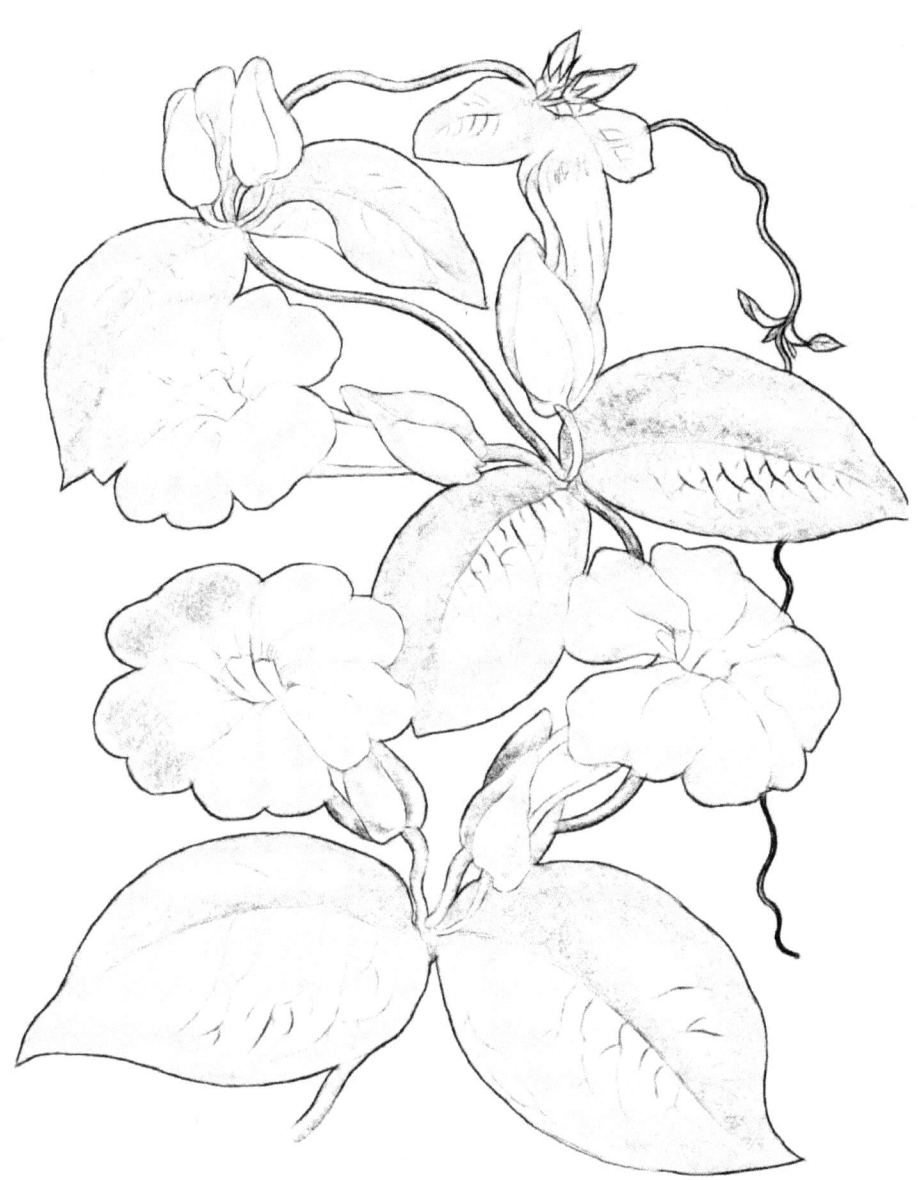

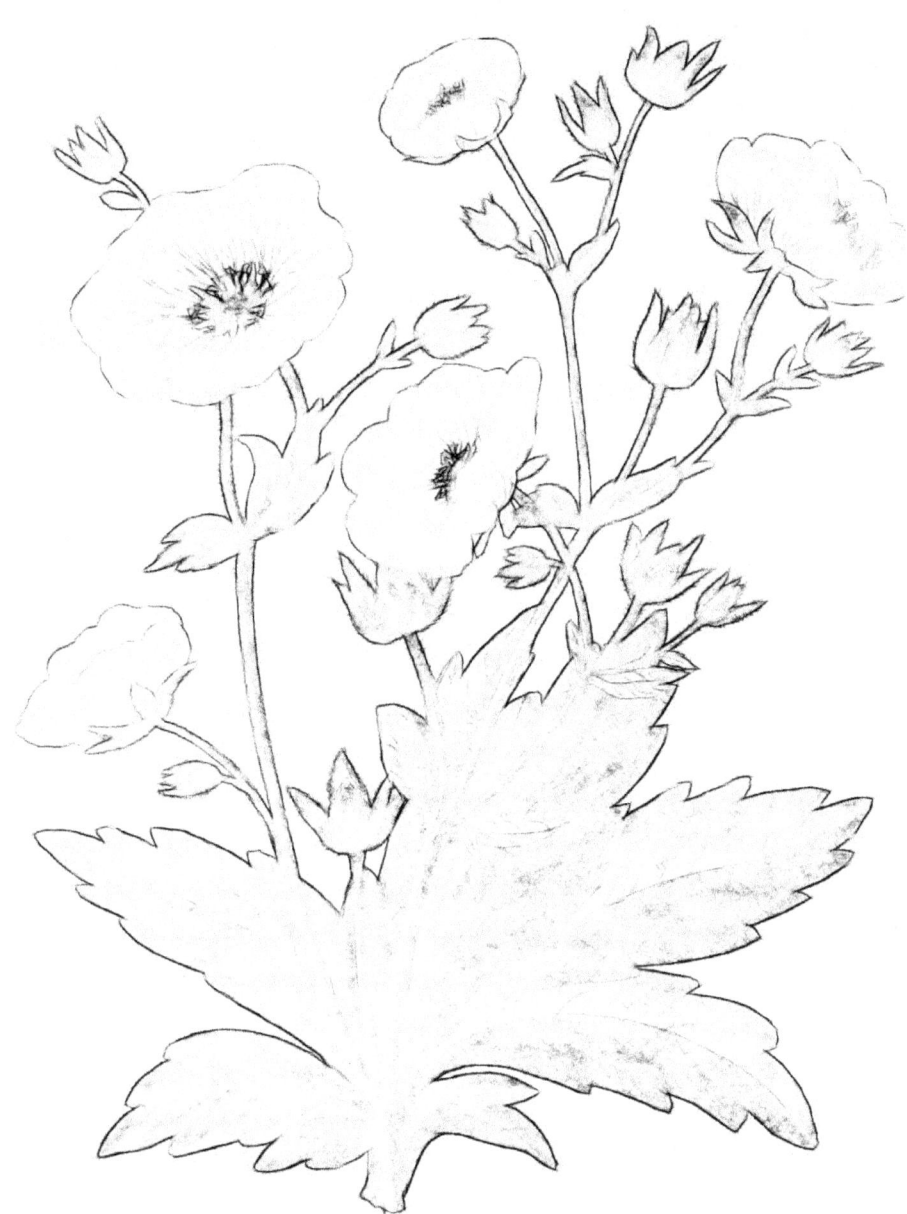

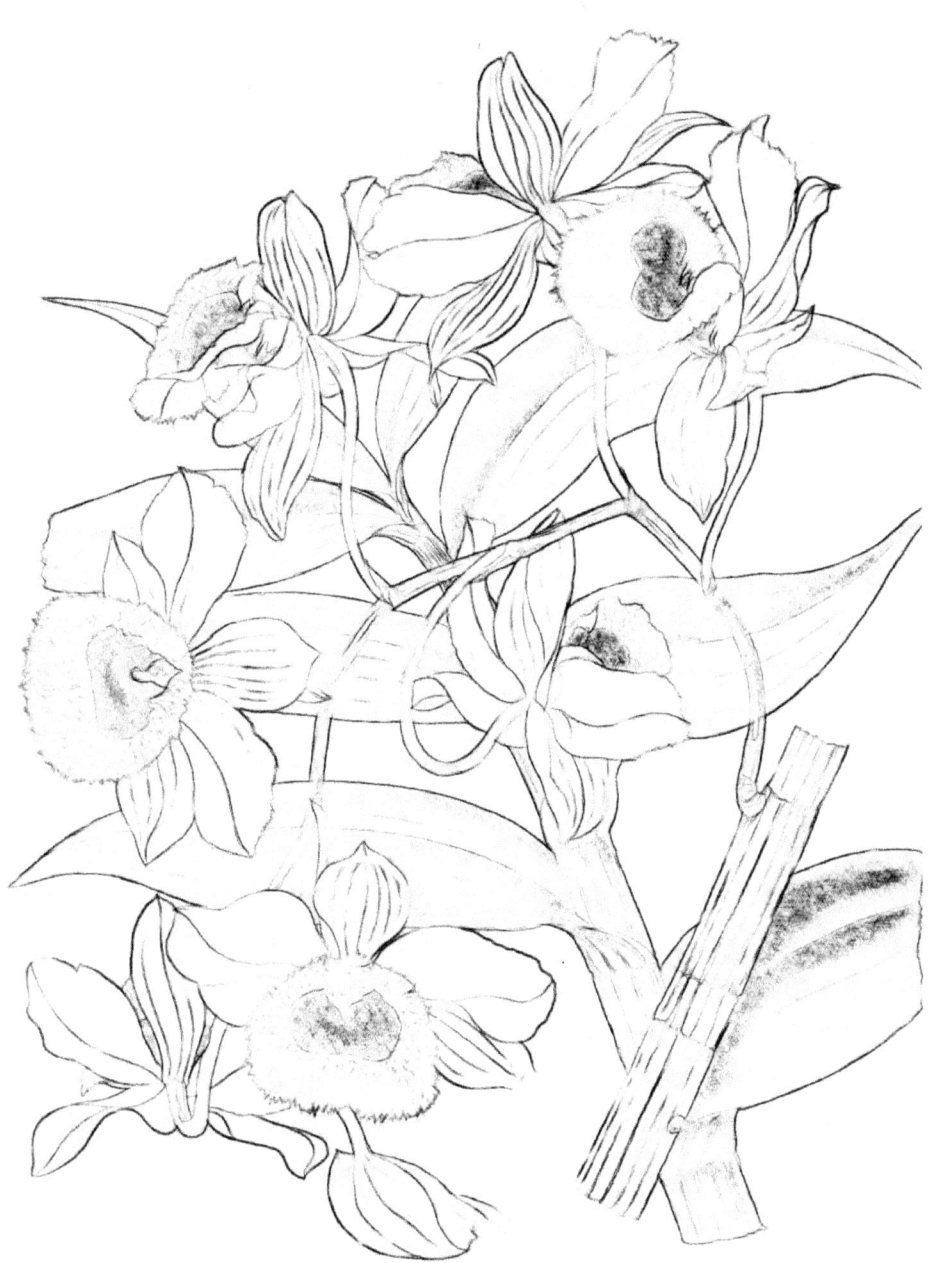

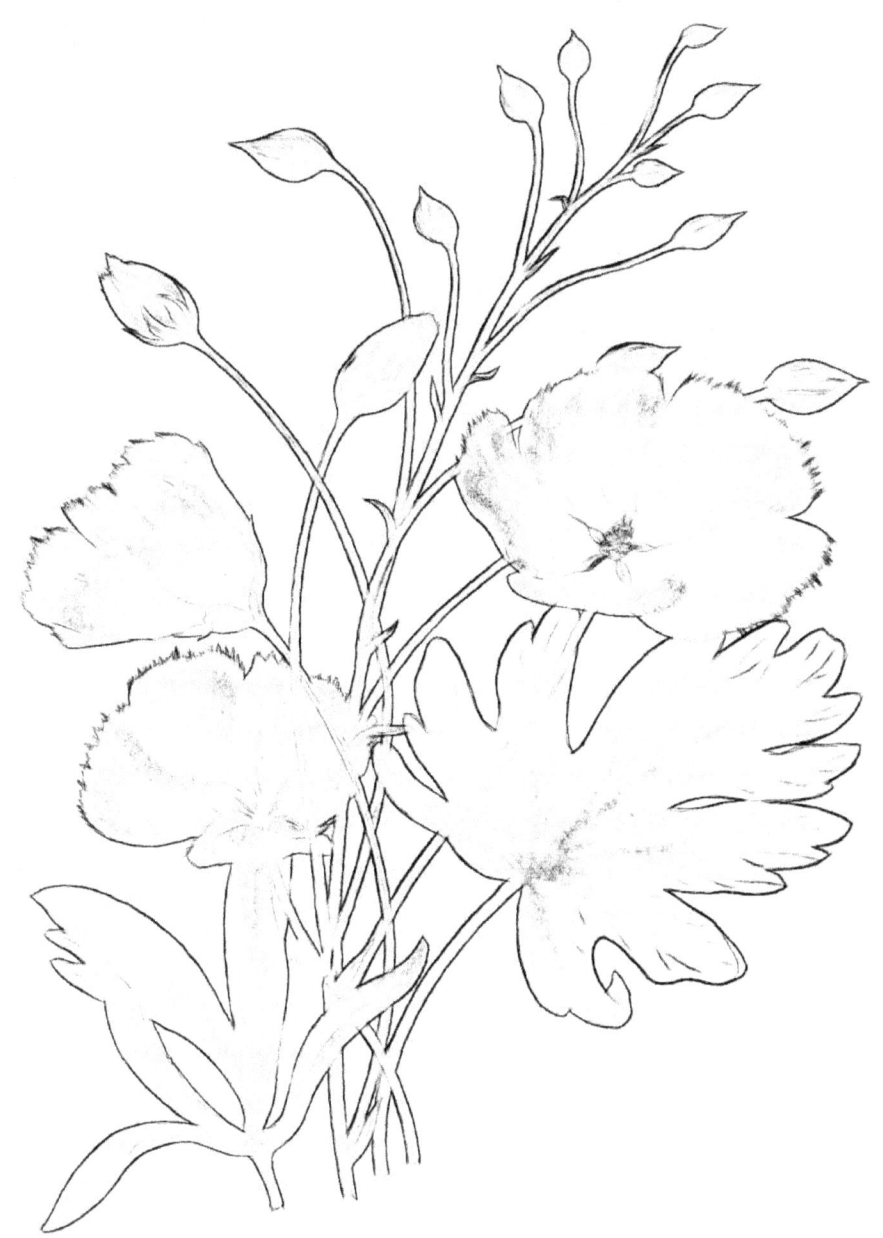

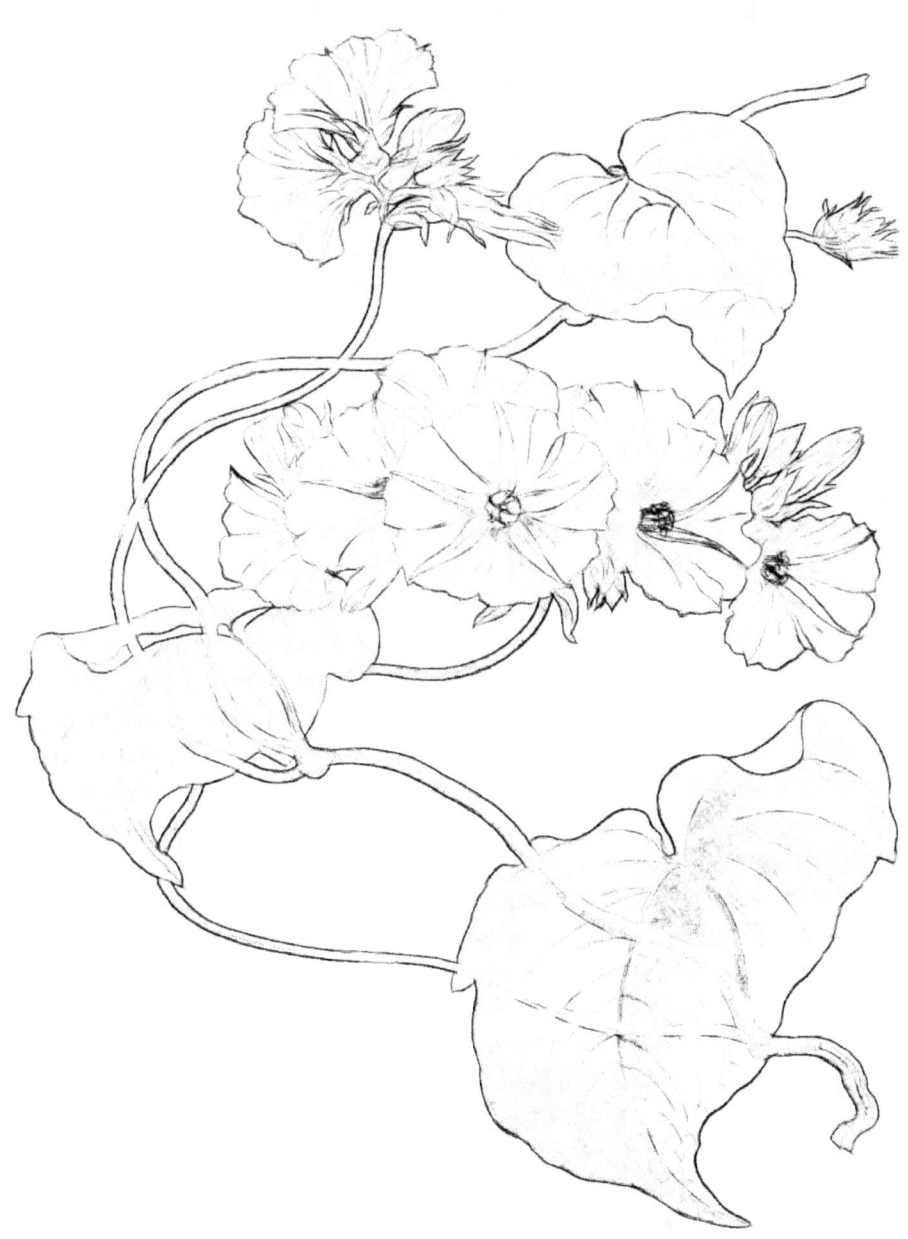

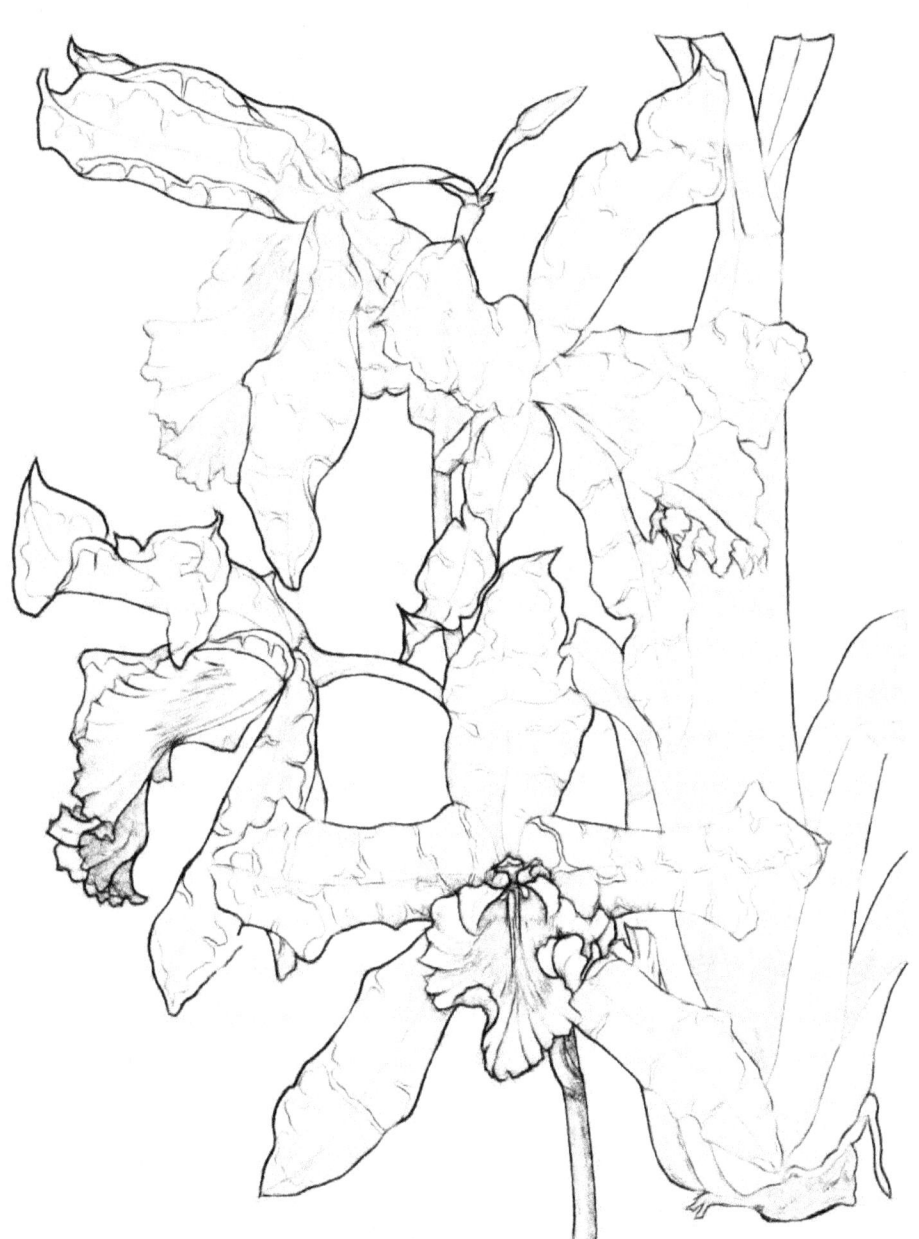

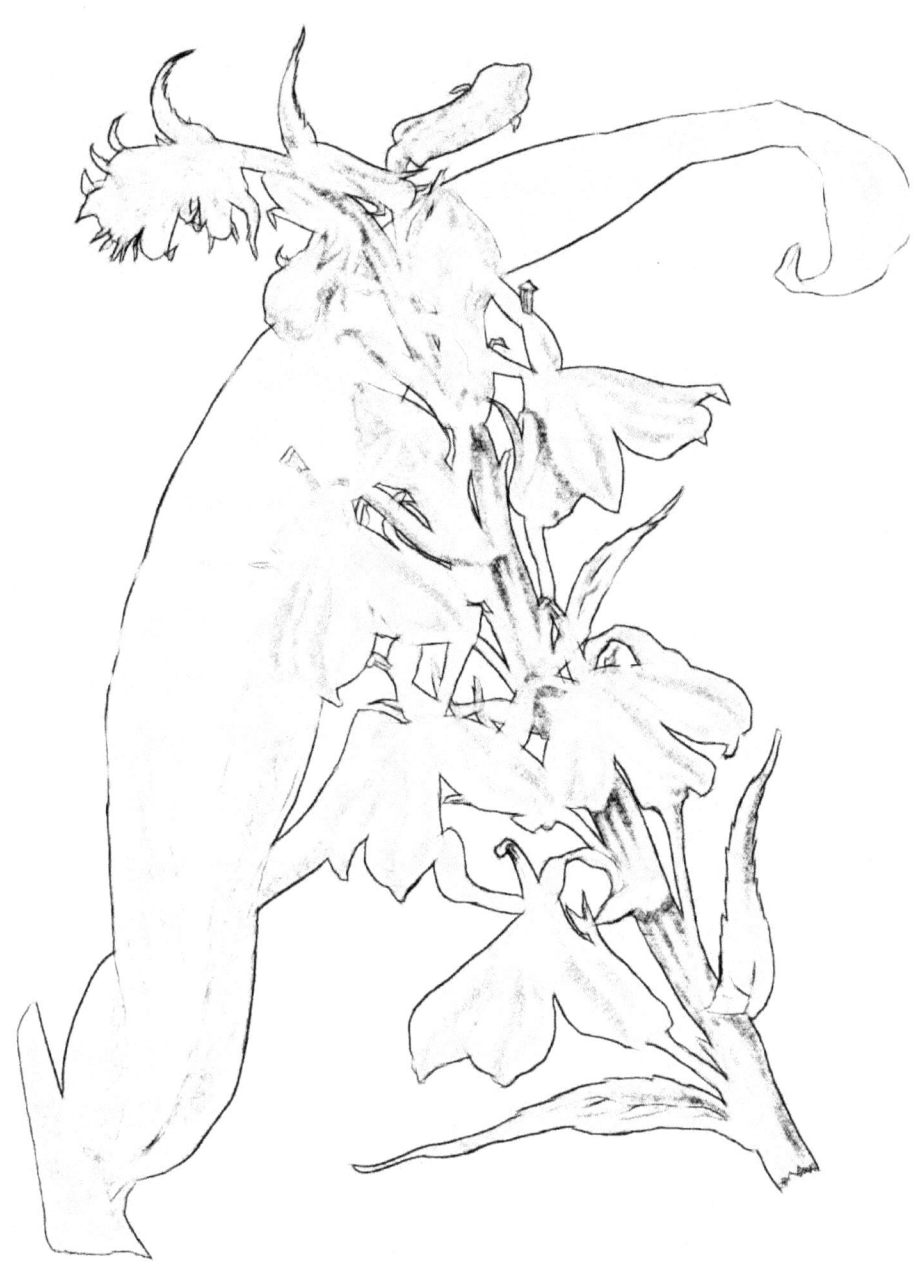

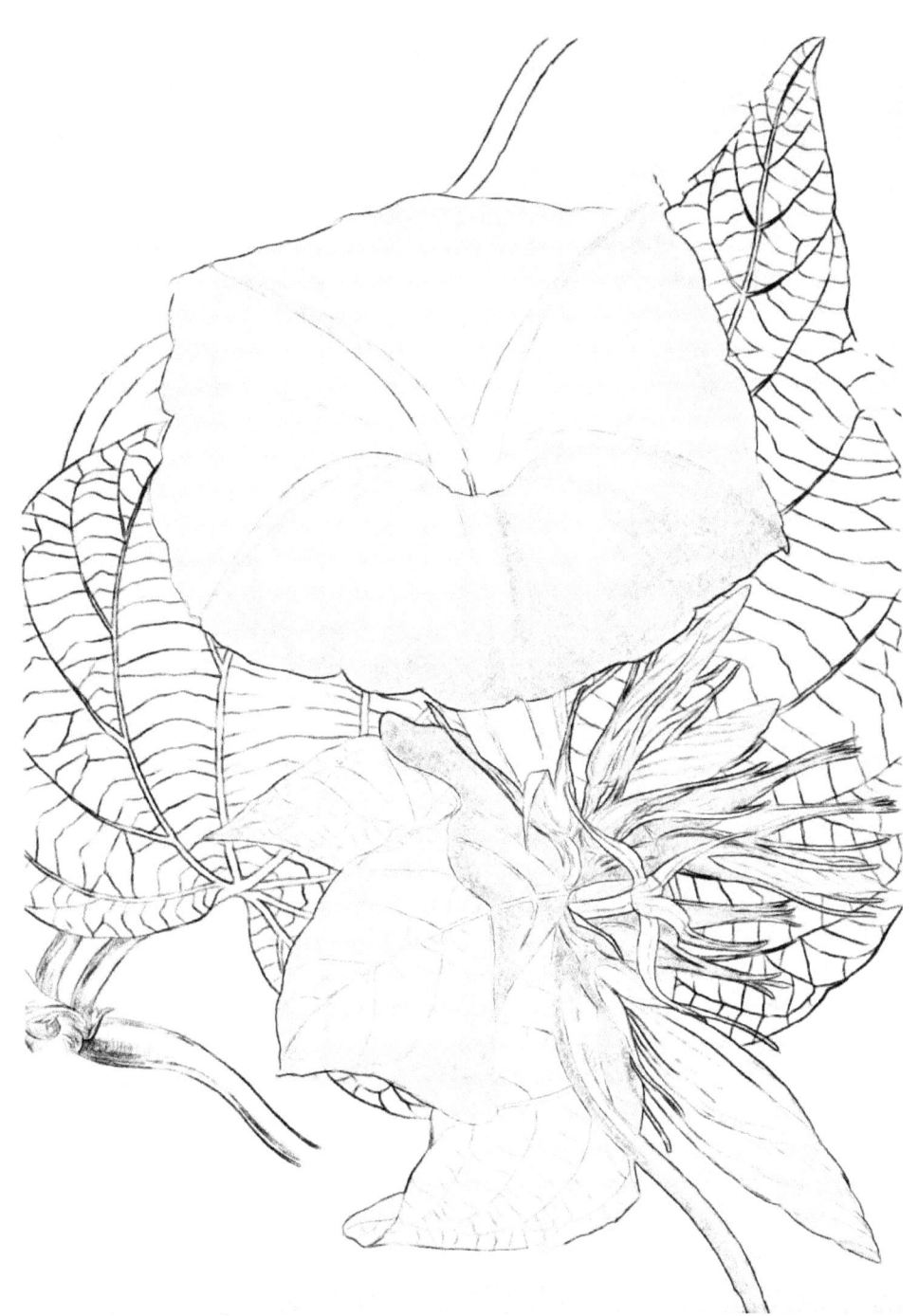

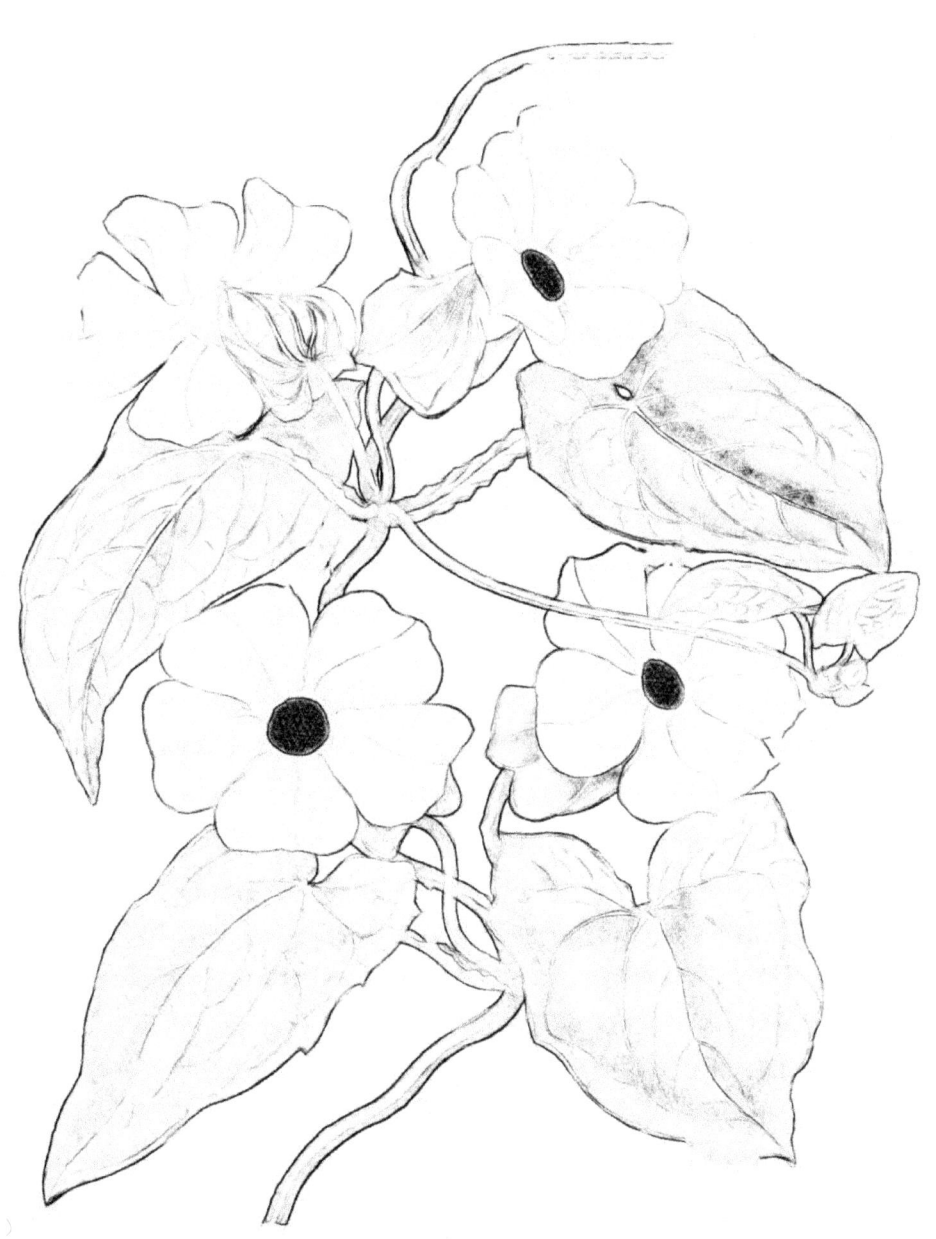

www.ingramcontent.com/pod-product-compliance
Lightning Source LLC
Chambersburg PA
CBHW080950170526
45158CB00008B/2433